A BRIEF HISTORY OF

WAREHAM

A BRIEF HISTORY OF

WAREHAM

THE GATEWAY TO CAPE COD

MICHAEL J. VIEIRA, PhD

Introduction by Angela M. Dunham

Charleston London

THE
History
PRESS

Published by The History Press
Charleston, SC 29403
www.historypress.net

Front cover: Images courtesy of the Wareham Free Library collection.
Back cover, top and bottom: Images courtesy of the Wareham Free Library collection.
Inset: Courtesy of the Library of Congress.

First published 2014

Manufactured in the United States

ISBN 978.1.62619.480.9

Library of Congress CIP data applied for.

To Audrey: Thanks for making history with me since 1973.

CONTENTS

ACKNOWLEDGEMENTS

Although I've often driven through Wareham, spent some time in the neighborhood (mostly at Tobey Hospital) when I was camp director of Cachalot Scout Reservation and did some shopping and dining in the town, I never really appreciated the history and people until now.

Thanks to Angela M. Dunham for her tour of the Wareham Historical Society sites and for agreeing to write the introduction to this book. I also appreciate the encouragement and support of Claire Smith, coordinator of the Wareham Summer of Celebration, and her committee.

Although there have been some excellent histories of Wareham, it took some searching to verify the old and add the new. The archives in the Stone Room at the Wareham Free Library were invaluable. The staff members were welcoming, and the original documents, especially photographs and postcards that you'll find in the text from that collection, really assisted in making the past come alive.

The nameless folks who have scanned and/or transcribed documents so that they are available via the Internet also deserve appreciation. Although the papers and files of the library were tremendous resources, the ability to access original materials from centuries past in the middle of the night online made this work less burdensome and, I hope, more valuable because of its primary sources.

It's important to give credit to the work done by Raymond A. Rider, Lynda Ames, Dr. James Rufus Lincoln and my Facebook friends who are part of the Wareham, Massachusetts: The Greatest Town on Earth group. Noble

Warren Everett's "History of Wareham," the online resources provided by Richard Griffith, the publications from the 200th and 250th anniversary celebrations and the *Images of America: Wareham* book by Susan Pizzolato and Ames all provided a great deal of information and support.

None of this would have been possible without the encouragement and support of J. North Conway. Jack has been a great person to write with, and his generosity in recommending me to author this book is truly impressive. He also connected me with Tris Coburn, who now serves as my literary agent, and with whom I hope to continue to work on future books and projects.

A writer needs the support of his family and friends, and I have been blessed with an amazing wife, Audrey, and wonderful kids, Anne and her husband, Al, and Jon and his friend Taylor. They've put up with my hours upstairs at the keyboard, and Audrey came along on more than one "road trip" to explore areas of Wareham and Onset. I also cannot imagine working on a project like this without having outstanding, long-term friends with whom I can relieve the stress. You know who you are, and you know you've become family. I appreciate it.

Thanks also go to Tabitha Dulla, commissioning editor; Julia Turner, project editor; and Dani McGrath, Northeast sales representative, from The History Press. They and their team have provided the resources needed to make this book a reality. I hope you enjoy it and learn a little more about the Gateway to the Cape. I know that I did.

MICHAEL J. VIEIRA, PHD

INTRODUCTION

FROM THE CHAIR OF THE
WAREHAM HISTORICAL SOCIETY

Wareham has a remarkably rich history, which the Wareham Historical Society proudly works to preserve and promote.

The Wareham Historical Society, which is a private organization and not run by town government, owns five buildings.

The Fearing Tavern, where town business was discussed and planned, was also a stagecoach stop. The Captain John Kendrick Maritime Museum honors a man who explored the Oregon Territory and was the first to start trade with Japan. His second in command, Captain Gray, was the first to sail the American flag around the world.

The Wareham Historical Society's three other buildings are the Methodist Meetinghouse (circa 1835), the Great Neck Schoolhouse (circa 1825) and the Great Neck Union Chapel (circa 1880). These buildings are open on weekends during the summer and by appointment.

Wareham's history starts with Native Americans harvesting shellfish from our beautiful shores and native cranberries from our land. Our town seal has the words *Nepinnae Kekit*, which means Summer Home.

Colonial settlement began with the Agawam Purchase, which is documented in *The Proprietors' Book*, dating back to 1685. Resilient colonists endured hardships and used our plentiful natural resources to survive and thrive. Cotton, iron and gristmills provided employment in a melting-pot community.

Shipbuilding was a thriving business bringing skilled craftsmen and investors to Wareham's waterfront. Saltworks also sprang up along our

shores, contributing to Wareham's early beginnings. The cranberry industry grew after the decline of the local iron industry, and it remains an important part of our community today.

The beautiful village of Onset has historically been a source of community pride. Travelers discovered our scenic shores in the early 1800s, when Onset became a nationally known retreat, and its shores attract many tourists each summer.

Wareham has been a community of hardworking people of many nationalities adapting to the changing times. Family names on local buildings and landmarks are a reminder of those who worked to improve the quality of life in our community.

It is important to preserve our historic homes and landmarks because they are what make our community's identity unique. They are what give our cities and towns character and charm, setting us apart from the rest. These places commemorate our proud heritage of strength and perseverance.

ANGELA M. DUNHAM
Wareham Historical Commission Chair
Wareham Historical Society President

THE SUMMER HOME

As the sun rose, it sparkled on the water, which seemed to go on forever. The native peoples undoubtedly found peace here on the shore of their summer home, or *nepinnae kekit*. The men fished, the boys searched for shellfish and the girls and women smoked yesterday's fish and prepared tonight's meal. A cool wind blew softly through the pines, and for thousands of years, all was well.

For what most historians estimate as more than ten thousand years, the Wampanoags—or "People of the First Light," also sometimes known as "People of the Dawn"—lived in the region that is now better known as southeastern New England. Their nation spanned from Wessagusset, now known as Weymouth, to Pokanocket, which is now Bristol and Warren, Rhode Island. Their lands included all of what are today Cape Cod and the islands of Natocket and Noepe, better known as Martha's Vineyard and Nantucket.

Long before recorded history, oral and archaeological evidence indicate that the native peoples farmed, fished and built communities. The Wampanoags were considered part of the Eastern Woodland People. They spoke *Wôpanâôt8âôk*, or "Wampanoag language," which is classified as a variant of the Algonquian language.

Although nearly lost, the *Wôpanâôt8âôk* Language Reclamation Project web page states, "It is considered to be the first American Indian language to develop and use an alphabetic writing system." This development has its roots with the European missionaries who helped develop an alphabet that would allow religious documents to be printed to aid in the conversion of the natives.

By the middle of the nineteenth century, there were no native speakers. Despite this fact, many Wampanoag words live on, not only in early documents but also in the names of streets, towns and areas of the region. For example, Wareham's native name, Nepinnae Kekit, continues to be part of the town seal. What is now Onset was mostly a wooded area stretching to the beach. Onset is thought to be a form of *onkowam*, which means the "Sandy Landing Place."

THE PEOPLE OF THE FIRST LIGHT

Although historians report that people in Mesoamerica and Peru were establishing communities thousands of years before, settlement by native peoples in New England was delayed by an ice sheet estimated to be one mile thick. According to Charles Mann, it wasn't until about 1000 BCE that Cape Cod and the adjacent areas emerged from the sea. In his 2005 article published in *Smithsonian*, Mann notes:

> *By that time the Dawnland had evolved into something more attractive: an ecological crazy quilt of wet maple forests, shellfish-studded tidal estuaries, thick highland woods, mossy bogs of cranberries and orchids, complex snarls of sandbars and beachfront, and fire-swept stands of pitch pine—"tremendous variety even within the compass of a few miles," in the phrase of ecological historian William Cronon.*

Although some historians estimate the Wampanoags numbered about five thousand, Nancy Eldredge in her article published by Plimoth Plantation estimated that there were forty thousand people in the sixty-seven villages that made up the Wampanoag Nation in the 1600s.

Throughout the region, communities of native peoples were developing. Along the rivers inland, like the Connecticut and the Charles, there were more permanent villages, but among the lakes, ponds and marshes of the colder uplands and coastal communities like Wareham, there were usually smaller groups. Most of them depended on wildlife and cultivated crops.

They traveled the rivers and streams in dugout canoes or in birch bark canoes that were lined with deerskin leather and sealed with pine pitch. They lived in *wetus*—or wigwams, which were round houses made from bent saplings covered in bark—or in longhouses made of cedar saplings tied

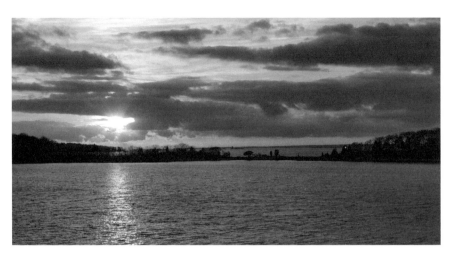

Part of the attraction of what is now Wareham has always been its sunrises and sunsets. *Lori E. Cooney.*

together. The framework of these larger, more permanent homes was also bent and covered with bark. Both lodgings often were also covered in woven cattail or rush mats. Both included a central fire pit under a hole, which let smoke out but could be covered when needed.

On land, the native peoples mostly traveled on foot. The trails they walked later became dirt roads for horse and cattle carts to traverse and even later became "shell roads," which were covered by oyster shells that were rolled and crushed. Many of these became paved streets that are currently in use. Most notable is Indian Neck Road, which has existed virtually unchanged over the centuries. Others include Bourne Point and Warren Point Roads, as well as Blossom Lane.

During the winter, the people headed inland, where they planted crops in early spring. These included the "three sisters"—corn, beans and squash—which could be planted in the same place. As the corn grew, the beans climbed up their stalks, and the squash covered the ground beneath.

WAREHAM'S IDEAL LOCATION

When the summer came, the tribe moved to what are now Wareham, Onset and other coastal communities. The native peoples traveled from

the wooded inner part of what is now Massachusetts to what is currently Wareham Shores and other seaside locations that make up Cape Cod.

In Wareham, they found excellent hunting and fishing spots, as well as native fruits and berries like the cranberry, which they used for food, as medicine and to decorate objects and their bodies. The area is surrounded by water with not only the Atlantic Ocean but also the Wankinco and Agawam Rivers, which flow into Buzzards Bay.

These two rivers merge to become the Wareham River, which includes the Broadmarsh River, Crab Cove, Crooked River and Marks Cove. Like the early settlers, the Wampanoags would have caught herring in the Weweantic River. *Weweantic* means "crooked" or "wandering stream." Alewives and other small fish bred in the river and ponds like Sampson's and Doty's, which was likely part of a cranberry bog that was near what is now Federal Pond. Some historical reports say that the herring were once so plentiful that they could be caught by the handful as they swam downstream.

Today, the Agawam River runs from Halfway Pond (in what is now Myles Standish State Forest) through East Wareham and drains into the Wareham River. It is considered to be one of the most important herring rivers in Massachusetts and, in 2013, was one of the few managed herring runs in the commonwealth.

The Wampanoags also harvested shellfish, and the water that surrounded Wareham and Onset was excellent to gather oysters, clams, mussels and quahogs. These were valued not only for food but also for their shells. The bright white and purple clamshell was used for jewelry but also was the basis for what is considered the first currency in New England: wampum.

In addition, there was wildlife in the wooded areas, including birds such as pheasants, duck and geese; deer; bear; rabbit; and others. Bows and arrows were used for hunting and for protection. Like other native peoples, the Wampanoags most likely prayed for the animal that was about to be killed and paid respect to it by using all parts of the animal. In addition to meat for food, the skins were used for clothing and the bones and hooves for tools.

With its acres of marshes and other wetlands, Nepinnae Kekit also provided an abundance of natural materials. Raymond Rider, in his history of the Fearing Inn, tells of how the natives used "cat-tails for stuffing mattresses and the down from cat-tails to pad moccasins and papoose board. From the fiber they wove coarse mats and baskets. They made dolls and other toys."

Cattails were also used to dress wounds, Rider continued, and the tender roots of the young plants were made into soup and jelly. Other roots were eaten as vegetables and stored for the winter.

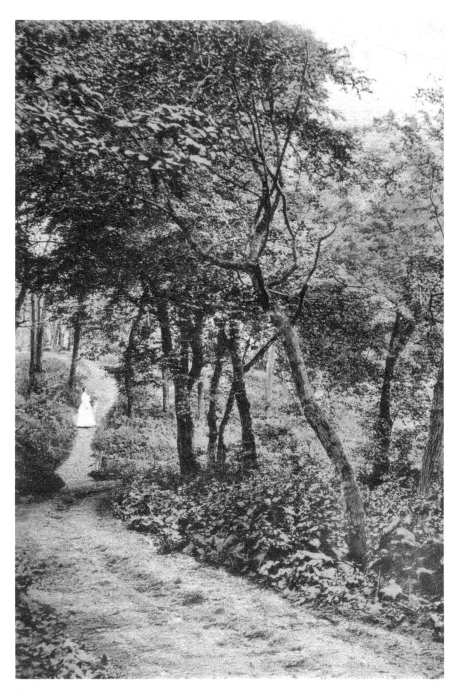

The trails where the Wampanoags walked continue to have an attraction. In 1909, Frank sent this postcard of Lovers' Lane in Onset to Miss Kitty, saying, "Come over soon and you may get an auto ride." *Wareham Free Library.*

And for many years, it appears that the native tribes were happy and satisfied. As Eldredge, a Nauset Wampanoag and Penobscot, noted:

> *The Wampanoag Homeland provided bountiful food for fulfillment of all our needs. It was up to the People to keep the balance and respect for all living beings and to receive all the gifts from The Creator. We were seasonal people living in the forest and valleys during winter. During the summer, spring, and fall, we moved to the rivers, ponds, and ocean to plant crops, fish and gather foods from the forests.*

And so, for many years, the native peoples lived in peace, although, even then, there were political boundaries and conflicts among leaders. It was up to the leaders—like Massasoit, who was also known as "Ousamaquin" or "Yellow Feather"—to maintain harmony. Massasoit was considered to be the grand sachem or chief of the Wampanoags. He was responsible for the entire region.

When local historian Lynda Ames and Wareham Free Library reference librarian Patty Neal were interviewed in a *GateHouse Media* article by Gretchen Grundstrom, they both pointed out on a map the "Indian Highway," on which the native people would travel by foot. The highway extended from today's South Wareham past what was the horseshoe mill and what is now the Decas School and up Lincoln Hill. It then continued on to Main Street past Village Green. After turning left and crossing the railroad tracks onto Route 28, it headed down to East Wareham, where it split to Plymouth or Cape Cod.

What became Main Street was just a "side road" to Onset and Great Neck. Another path headed from where the Weweantic River meets what is now Marion all the way to the Narrows Bridge. This outlines the section of Rochester that would be joined with the Agawam Purchase to become Wareham.

THE FIRST TOURISTS

By about 1000 CE, there is little doubt that visitors had arrived in what is now the Americas. Archaeological evidence of Viking explorations have been documented early in the millennium, and some say Prince Madoc of Wales made two trips to North America later in about 1170. Others

credit the Chinese, the Muslims and the Portuguese for "discovering" the New World.

By the fifteenth century, records show that Portuguese explorers, such as João Vaz Corte-Real and his sons, explored what is now New England before Christopher Columbus and Giovanni Verrazzano arrived at other American shores. The Corte-Reals reportedly sailed up what is now the Taunton River and explored the other regions.

In 1602, Bartholomew Gosnold named the now well-known landmass "Cape Cod." Samuel de Champlain charted the harbors of the region, and Henry Hudson landed in the area in 1609. Captain John Smith also noted it on his map of 1614.

So it is likely that these explorers made their way to the beaches in Onset and Wareham. And even if they did not land on any of the town's more than fifty miles of shore, the iron pots and other items that were the result of the trading would have made their way to the region.

For the most part, the natives were apparently welcoming to the visitors, but part of that might have been because they recognized the value of the items that the Europeans brought with them. The strange, oddly dressed foreigners had copper kettles, steel tools and colored glass that they would trade for furs and food.

Sometimes the friendly visitors took their own souvenirs. Records show that some, such as the Corte-Reals, brought back native people with them to Europe.

Gaspar Corte-Real was surprised to find, when he captured fifty indigenous people from Maine, that two of them were wearing items from Venice, including silver rings and a broken sword. Perhaps the most famous of the native captives was Tisquantum, better known as Squanto.

Most people have heard the stories of this native who spoke English and taught the Pilgrims to plant corn. Squanto lived in Patuxet, which now includes Plymouth. There is little doubt that he was familiar with the paths and people in Wareham and Onset.

In 1605, Squanto, along with four others, was captured by Captain George Weymouth, who was exploring the coast for Sir Fernando Gorges, the owner of the Plymouth Company. Squanto was taken to England and trained as a guide and interpreter.

Squanto was en route back to his home in 1614 as part of an expedition led by the English explorer John Smith, when Squanto was kidnapped by Thomas Hunt, one of Smith's lieutenants. Squanto, along with several other Wampanoags, was sold to Spanish friars who instructed him in the Catholic faith and allowed him to try to return home to Patuxet.

What Squanto did not know was that things were not good at home.

For the Wampanoags, the ten years previous to the arrival of the Pilgrims had been the worst of times beyond all imagination. Micmac war parties had swept down from the north after they had defeated the Penobscots during the Tarrateen War (1607–15), while at the same time the Pequots had invaded southern New England from the northwest and occupied eastern Connecticut. By far the worst event had been the three epidemics that had killed 75 percent of the Wampanoags. In the aftermath of this disaster, the Narragansetts, who had suffered relatively little because of their isolated villages on the islands of Narragansett Bay, had emerged as the most powerful tribe in the area and forced the weakened Wampanoags to pay them tribute.

In 1619, Squanto returned back to his home on another of John Smith's voyages. But his home was no more. The Patuxet village, which was in and around present-day Plymouth, had been decimated by a series of plagues caused by smallpox, leptosis or another disease probably brought by the Europeans.

THE AGAWAM PEOPLE

The native people in Wareham did not fare much better.

They were called the Agawam people, also known as *Agawame* or *Agawaam*, which mean "land beneath water." The name was a nod to the many marshes and waterways of the area.

Early histories of Wareham note that by the time the Pilgrims landed in 1620, the Agawams were reduced to "five able bodied survivors." This is the reason why, when the Pilgrims arrived in nearby Plymouth in December 1620, much of the coast was relatively unoccupied.

Historians agree that the settlers were greeted by Samoset in English. Later they met Squanto, who set up a meeting with Massasoit, the sachem of the Wampanoags. Although apprehensive of the English, Massasoit agreed to a trading treaty and hoped to live in peace with the Pilgrims.

During the first winter, the English were not prepared for the climate and suffered a great deal. Most of the 102 colonists stayed on the *Mayflower*, and nearly half—42—died.

It could have been worse. The natives helped the settlers survive that first winter and taught them to plant and cultivate the land. One result

was the harvest feast in October, which most historians agree was the first Thanksgiving. But not all of the indigenous people were happy about the new colonists' arrival.

Corbitant was the sachem of the Pocassets. The Pocassets made their home in Tiverton, Rhode Island, and Fall River, Massachusetts. They were known to hunt and travel through much of Rhode Island, including the islands, and venture through southeastern Massachusetts up to what is now Cape Cod and as far away as present-day Attleboro and Duxbury.

It is widely accepted that Corbitant had at least one incident involving the Plymouth Colony. Historians report that Corbitant had an "altercation" in present-day Middleborough with Squanto and Hobomok in 1621 because he was not in favor of their close ties to the colonists. Myles Standish and a team of ten men attacked the Wampanoags at Nemasket, but by then, Corbitant had released Squanto.

From the bluffs of Onset to the rivers of Wareham, things would never be the same for the Wampanoags.

EARLY WAREHAM SETTLERS

In 1621, the merchant-adventurers who had financed the original trip of the *Mayflower* to the colonies from England sent a second English ship, *Fortune*, to Plymouth. Among the English colonists were Edward Bompasse and his family. Over the years, the name would become Bumpas and Bump, among other spellings. From all accounts, the family worked hard purchasing land and cutting the timber, which they then cut into lumber in their sawmills and used to build homes in the Wareham area.

Raymond Rider, the well-known Wareham historian, wrote that Bompasse became part of the Plymouth Bay colonists, better known today as Pilgrims. They were members of the "Brownists" or "Independents," a group of dissenters from the Church of England who were strict in religious and daily habits. After landing in what is now Provincetown, they settled in the Plymouth area.

In 1627, Plymouth Colony established the Aptucxet Trading Post in what is now Bourne, Massachusetts. It was there that what many historians consider to be the first trade agreement in the New World was signed. This treaty between Plymouth Colony and the men in England who financed the colony, New Amsterdam (New York) and the native peoples, led by Quachatosset, sachem of Manamet, included "lands from the Pine Hills of Plymouth to Sandwich, including Sagamore, Bourne, Wareham and Onset." The agreement primarily involved the fur trade.

This trade agreement also introduced wampum as the first currency in Massachusetts. The lowly quahog, or hard-shell clam, was declared legal

tender in 1637. By 1641, six beads of wampum equaled one penny of English currency.

About ten years later, the Pilgrims of Plymouth Colony were joined by a group of mostly Puritans who formed the Massachusetts Bay Colony. They made their homes near what is now Boston Harbor. These settlers were mostly better educated, wealthier and politically connected.

Tense Times Arise

As more English colonists arrived in New England, tensions increased—and not just between the immigrants and the natives. By the 1630s, the Pequot War pitted the Pequots, who migrated from the upper Hudson River Valley toward Connecticut, against their enemies, the Mohegans.

The Pequots allied with the Dutch colonists, and the Mohegans joined the Narragansett tribe, who had allied with the English from the Massachusetts Bay, Plymouth and Saybrook Colonies. After a major battle in Mystic, Connecticut, the Pequots signed the Treaty of Hartford in 1638.

In the midst of this conflict, John Fearing arrived in 1638 and settled in what is now Hingham. He and his wife, Margaret, had a son, Israel, in 1644. The Fearings would become prominent landowners in Wareham.

At about the same time (between 1635 and 1640), most historians estimate that Weetamoo (also known as Nanumpum and Tatapanum) was born. She was the daughter of Corbitant, sachem of the Pocassets, and probably grew up in the tribe's largest village, Mettapoisett. Not to be confused with the town of the same name near Wareham, Mettapoisett is considered by historians to be located in what is now present-day Gardeners' Neck in Swansea. Reports indicate that this native settlement consisted of about five hundred acres of marsh and meadowland on the east side of Coles, or Swansea, River in what are now the towns of Swansea and Somerset, Massachusetts, and Barrington and Warren, Rhode Island.

Because Corbitant never had sons, Weetamoo, as Corbitant's eldest child, would be the next sachem. Based on stories that have been passed on over the centuries, Weetamoo was as skilled as any Pocasset boy in fishing, hunting and swimming. She also was reported to have undergone the "vision quest," normally reserved for boys. In addition, she mastered the duties of other women, including cooking and smoking and preparing hides for clothing. From many historic reports, she was also an excellent diplomat.

Her father, Corbitant, remained loyal to Massasoit, so much so that Weetamoo married Massasoit's son Wamsutta, who became sachem of the Wampanoags in 1661 when his father died. Also known as Alexander, he would lead the tribe for only a short time. In 1662, he was accused of selling land independently from the English. He was brought to Plymouth Court and, soon after being questioned, got sick and died.

It is not known how involved, if at all, Weetamoo might have been in the negotiations with the English of Plymouth Colony that led to land deals. According to Edward Lodi's book *Women in King Philip's War*, records show that Weetamoo did file a complaint in Plymouth Court in 1659 against Wamsutta, claiming that she wasn't paid for land she owned that he sold. She made another complaint in 1662 about another piece of land. These may or may not have been related to the lands in Agawam, but the timing is interesting.

THE AGAWAM TITLE

There were two early agreements involving the area that is now Wareham, then known as Agawam. One was signed in 1655, but another involved a more specific purchase in 1665 (signed in 1666) from the Wampanoags.

According to Sibyl Jerome's *Wareham Bicentennial* text, the details of the "Agawam Title" were as follows:

> *Know all Men by these Presents, That we, Nanumett, Weenucket, Aconoootus, Attaywanpeek, Awanoo, Awampoke, and Assaankett, alias Peter, natives of New England, in the jurisdiction of New Plymouth in New England in America, do acknowledge that for, and in consideration of, the full and just sum of twenty-four pounds and ten shillings, to us paid by Capt. Thomas Southworth, Nathaniel Warren, William Clark and Hugh Cole, of the town of Plymouth aforesaid, in the jurisdiction aforesaid, gentlemen, wherewith we do acknowledge ourselves, and everyone of us, to be satisfied, contented, and full paid, do bargain, alienate, sell and confirm from us, the said Nanumett, Weenucket, Aconoootus, Attaywanpeek, Awanoo, Awampoke, and Assaankett, alias Peter, do acknowledge ourselves, and every one of us, to be satisfied, contented and fully paid, and therefore, and of every part and parcel thereof, do exonerate, acquit, and discharge the said Capt. Thomas*

Southworth, Nathaniel Warren, William Clark and Hugh Cole, they and everyone of their heirs, executors, administrators, and assigns, forever, by these presents have freely and absolutely bargained, alienated, and sold, enfeoffed and confirmed, and these presents do bargain, alienate, sell and confirm from us the said Nanumett, Weenucket, Aconoootus, Attaywanpeek, Awanoo, Awampoke, and Assaankett, alias Peter, and our heirs to them the said Capt. Thomas Southworth, Nathaniel Warren, William Clark and Hugh Cole, in behalf of the town of New Plymouth, their and everyone of their heirs and assigns forever, two certain tracts or parcels of land, the one being called Weeyvancett Neck, and another parcel adjoining the aforementioned Weeyvancett Neck, being bounded by a salt water river on the south, and which river runneth into Manomet Bay, and on the east side with a great salt water cove or river which runneth into the same bay, and so bounded by up along with a brook unto the head thereof, and so to a meadow lying some space above the head of said brooks, and so to a great pond lying about northeast near a quarter of a mile from the said meadow, all the said meadow being included within the said bounds; the other parcel of land of the two above named, abutting on the tract or parcel of land which the town of Plymouth bought of us Acanootus, Awampoke, and Attayampeek as appears by a deed under our hands bearing the date Anno Domini 1665, and from the westernmost bounds expressed in the said deed, two miles and a half into the woods running upon a line northeast and by north, the upper end of the said two miles and a half running along a swamp side until one side of the said swamp parteth and runneth away near east and the other part more northerly, which place is agreed on by us the said Nanumett, Weenucket, Aconoootus, Attaywanpeek, Awanoo, Awampoke, and Assaankett, alias Peter, to be the bounds of the said northeast and north lines, and so to run upon a straight line through the woods to the forenamed pond which lyeth to the northeast of the forenamed meadow. To have and to hold all the said parcels or tracts of land so bounded as aforesaid with all and singular, the appurtenances whatsoever, within, and between, and belonging to the two said parcels or tracts of land bounded as aforesaid, unto them, the said Capt. Thomas Southworth, Nathaniel Warren, William Clark and Hugh Cole, in behalf and to the use of the town of Plymouth, assigns forever, the said premises, with all and singular the appurtenances belonging thereunto, or to any part or parcel thereof, to appertain unto the only proper use and behoof of them, the said Capt. Thomas Southworth, Nathaniel Warren, William Clark

and Hugh Cole, in the behalf of the town of Plymouth aforesaid, to their, and every of their, heirs and assigns forever, to be holden as of his Majesty, his manor of East Greenwich, in the County of Kent, in free socage, and not in capety, nor by Knight's service, nor by the rents and services thereof and thereby due, and of right accustomed warranting sale thereof, and of every part and parcel thereof, against all persons whatsoever that might lay any claim thereunto, or to any part or parcel thereof forever, giving and granting liberty unto the said Capt. Thomas Southworth, Nathaniel Warren, William Clark and Hugh Cole. Or any whom they shall appoint to record and enroll these presents, either in his Majesty's court at Plymouth, aforesaid, or in any other places of public records, according to the usual manner of enrolling evidences in such case provided.

The document was "signed, sealed and delivered" in December 1666.

CONNECTIONS TO KING PHILIP'S WAR

In spite of the apparent civility demonstrated by the Agawam agreements, trouble began brewing between the English and other settlers and the native tribes. The sachem queen Weetamoo and others believed that her husband, Wamsutta, also known as Alexander, who succeeded Massasoit as sachem, was poisoned. His brother Metacomet, also known as Philip, agreed, and many believe this event contributed to the war in 1675 that has become known as King Philip's War or Metacom's Rebellion. In addition, the disputes over landownership and the right to sell it made relationships between the native people and the colonists more difficult.

Major Benjamin Church was one of the Puritan leaders who emerged during the war. During the summer of 1675, another female sachem, Awashonks, formed an alliance between her tribe, the Sakonnets, and the English under the leadership of Church. Church was supposed to meet the tribe in Sandwich, but it had already left. The following day, he met the natives in Agawam, which would have contained modern-day Wareham. Reports suggest that Church and his men stopped at the Sippican River and then crossed Mill Creek, heading into what is now Mattapoisett. Church encountered the Sakonnets feasting on fish and clams and dancing around a bonfire of pine.

In addition to the alliance with the Sakonnet and other native peoples, many towns had militias. Although much of the fighting occurred in areas ranging from Swansea, Massachusetts, to Maine, the events impacted the region. In the spring of 1676, Plymouth Plantation was attacked.

By the summer, the war had turned in the colonists' favor. Weetamoo drowned in the Taunton River in August 1676, and her body washed ashore in Swansea. Nobody knows if the drowning was an accident or related to the war. Days later, Metacomet and Weetamoo's fifth and last husband were killed in Rhode Island. The war was over except for a few skirmishes in Maine in 1677.

With the native tribes nearly annihilated, the English went about their business of settling the New World. At first, the residents of towns were probably overseers who occupied the area during warmer months in order to take care of the animals and crops. During the winter, they most likely returned to the colony, but that system soon changed.

By 1670, the Bump family had a sawmill operating on the Wewantic River and later added another sawmill on the Wankinco River near the dam. The Rider history describes these early mills:

> *These saw mills operated a saw with 2-inch teeth that went up and down in a recessed frame, with greased blocks attached to the hardwood frame allowing a minimum of friction as they moved in the recesses of the fender posts. A crank and pitman rod attached to the saw frame was powered by a water wheel mechanism. Although very inefficient for the power obtained, it was nevertheless faster and less exhausting than sawing by hand.*

The Bump family weren't the only folks who saw the value in the land that would become Wareham. Although the leaders in Plymouth were careful to retain control over the jurisdiction, their need for funds resulted in the sale of the east part of Wareham to a group of settlers in what has become known as the Agawam Purchase.

The Agawam Purchase

In 1678, the Agawam (or Agawame) Purchase was leased from Plymouth for a term of seven years. This eight-thousand-acre parcel was sold for £280 by the town in 1682 to raise funds to build a new meetinghouse in Plymouth. The purchasers were John Chubback, Samuel Bates, John Fearing, William

Beale, Seth Pope, Joseph Bartlett and Joseiah Lane, as noted in Jerome's history. The proprietors divided the land into six sixty-acre parcels to "build any house or housen upon" and six tracts of meadowland. There was also a lot for a public gristmill on the Agawam River and a "burying acre," which is now known as the Agawam Cemetery.

Sybil Jerome, in the history he wrote for the town's bicentennial, describes the purchase as follows:

> *The Agawam Purchase was bounded on the east by Cohasset Narrows (now known as Buttermilk Bay), up Red Brook to the head thereof, crossing White Island Pond to the west bank, then westerly to Tihonet, down the brook to Agawam River and by the river to Wankinco River, and down that river through the Narrows to Buzzards Bay.*

Tihonet was not annexed from Carver and Plymouth until 1827, but the area was very much part of the natural landmass that was settled in the 1600s.

Rider's history relates the "legend" of how Tihonet came to be. An early settler lived on a lot and "exercised the right of ownership of the land around him, so far as to cut the best timber and market it." When another settler was shown the area and asked who owned it, the guide said, "I own it." When he discovered the "trick," the potential buyer "gave the old man the name Ti-Own-It, by which he was afterward called and that section, with slight alteration in the name has borne his name ever since."

The Chubbuck and Besse families settled in Tihonet, and within a few years, the Agawam Purchase was divided even more. Among the early names, Rider notes, were Ebenezer Burges, Gershom Gifford, Thomas Tupper, Isaac Wilder's heirs, Timothy Brown, John Bourney, Israel Fearing, David Bates, Joseph Hersey, Joseph Warren, John Gibbs, Jirey Swift, Oliver Norris and Adam Jones.

Joseph Warren is considered to be the first nonnative to build on what is now "Indian Neck." Records indicate that the land was purchased in 1655 from the Wampanoags and was recorded in 1682 in Plymouth. By 1688, Warren was living on the land in what was "the first house mentioned in the records of 'Agawame,'" according to *Wareham 1776–1976: Revolution and Bicentennial* by Sibyl Jerome, which also suggests that Warren Point was named for this first settler.

The Public Center

Around 1690, the Bump family built a dwelling that is now part of the Fearing Tavern, located in the center of town. Isaac Bump, the miller, lived there. He was the grandson of Edward Bompasse and related to John and Priscilla Alden of *Mayflower* fame. Bump not only built the dwelling but also owned about three and a half acres on the millpond, including the dam holding the pond on the south side.

The wood for the house most likely came from local sawmills owned by John Bump and his brother Isaac, although some say the mills were owned by John and Jacob. The Isaac who lived in the house was John's son and Isaac's nephew. Isaac the miller owned gristmills on Bump Brook, which is now Rose Brook, on the Wankinco River and possibly on the Weweantic River.

More than three hundred years later, parts of the original Bump home are still intact. Originally, the home faced north and consisted of two lower rooms, two upper rooms and two fireplaces and ovens connected to two chimneys. In addition, there was a lean-to and cellar.

The Publick Room in the Fearing Tavern remains virtually unchanged in 2013. *Michael J. Vieira.*

The Fearing Tavern is now owned by the Wareham Historical Society, and tours are given of the building. According to the Wareham Historical Society's "Tour Guide to the Fearing Tavern in Wareham, Massachusetts," the lower ceilings in the Publick Room and others indicate that these were the original areas in which Isaac Bump lived. The home also served as a town meeting place from 1690 until 1739, when the meetinghouse was built. A unique curved wall was designed to reflect heat from the big fireplace in the kitchen into the Publick Room. The lean-to is now part of the taproom.

No doubt, much of the conversation at town meetings focused on the power of the ministers and the Puritan rule under which only church members could own land. As a result, in 1670, only about 1,100 of the 2,500 residents were considered "freemen." Although they could not hold office, the ministers were powerful leaders in the early days of the colony.

The power of the ministers began to decline on October 7, 1695, when a charter by King William and Queen Mary was issued. The colonies of Massachusetts Bay and the provinces of Maine, Arcadia and New Plymouth, including the Cape, united and became the province of Massachusetts Bay in New England. The English Crown retained control over the colonies, including the right to appoint a governor.

The role of the English governor in the province was firmly established and would continue to grow until the Revolution. But still, in 1701, the settlers of Wareham set aside "two lots of land and one of meadow…for the ministry."

THE FIRST HIGHWAY

As more settlers moved into the area, good roads to travel from settlement to settlement became necessary. Like the highways that followed it, the "first highway" in Wareham was the main road and, in 1701, ran east to west, but there were "other ways [that] led to the house of every settler, some of them open, and some through gates and bars," according to the 1867 *History of Wareham*.

Early settlers also used old Native American paths to harvest shellfish, especially oysters, from the Weweantic River. Local historian Lynda Ames told *GateHouse Media* reporter Gretchen Grundstrom in an interview in 2012 that Quasuet, now known as Cromesett, and Swift's Neck, now Swift's Beach, were also prime harvest points.

The public center of town, according to the Wareham Preservation Plan, was Center Park, originally known as Fresh Meadows. There was also an early settlement near where Agawam Cemetery is located on Great Neck, as well as other communities in South Wareham near the junction of Weweantic River and Mary's Pond Road.

One of the oldest houses in town is the Burgess House on Great Neck Road, which dates back to the late 1600s or early 1700s. Other houses from the period survive on Elm Street, Lincoln Hill and Great Neck Road.

The *History of Wareham* provides the following description of what would become the town:

> *The land southerly of Agawam, is indented with many coves, forming numerous peninsulas, or necks, as they are here called. There are also numerous islands, among them Wjckett's, named for the Indian who owned it; Ousett, on which the credulous believed money was buried, and where lights were formerly seen on stormy nights, and even the money chest has been seen by curious searchers! Little Bird, Tinis, besides the cluster of islands in Little Harbor. There are two beaches made by the waves of Buzzard's Bay, and the extensive flats yield many shell fish. There are several ponds, and numerous valuable streams of water, in this section, among them Red Brook, colored by the iron-oar* [sic] *bed over which it passes, and the Agawam river, a valuable manufacturing stream. The wood is mainly pitch-pine.*

It is not known at what time the west end of the town was first settled. The lands were granted by the Virginia mode, called singling. To each proprietor was given a warrant stating that he was entitled to a certain quantity of land. This warrant he could assign or locate where he pleased, in one or more lots or in any shape. Of course, all aimed to secure the best land, and surveyors, not always knowing what another had done, often covered lots more than once, which led to litigation and trouble. Many odd strips called gores were also left.

Even though nearly a century had passed since the colonies were founded, the English settlers continued to operate very independently, although the English rule was slowly making its influence known. It is not clear how many settlers were living at that time in what was once the Wampanoags' summer home, but Israel Fearing was one of the first English people who made it home. By 1715, he owned more than five thousand acres and was commissioned by King George I to be the first justice of the peace.

Wicket and Onset Islands are featured in this circa 1907 postcard. *Hugh C. Leighton Co.*

By the eighteenth century, there was a movement toward incorporation by the settlers, who wanted to make the areas of the colonies official towns in the eyes of the Crown, and Wareham's residents were no different.

THE TOWN IS INCORPORATED

By the beginning of the 1700s, several families who would become notable in Wareham were living in the part of Rochester then called Sippican and the part of Plymouth that would be joined to form the new town. Most had been living in other parts of the colonies prior to this time. These families included the Bateses, Chubbucks, Fearings and Norrises from Hingham; the Hathaways from Dartmouth; the Sampsons, Saverys and Sturtevants from Plymouth; the Briggs, Bumpuses and Dotys from Rochester; and the Besses, Blackmers, Bournes, Burgesses, Gibbses, Hammonds, Nyes, Perrys, Saunderses and Swifts from Sandwich.

In the Agawam Purchase, there were house lots, gristmills and a cemetery, which also contained the "town pound" for stray animals. An appointed pound keeper cared for the animals and collected fees from their owners for services. Cattle, sheep and horses were pastured on Wankinquoah Neck, and although most hogs were kept throughout the area, there was a public pasture on Hog Island for swine.

In 1735, land was set aside for a meetinghouse not far from the Fearing Tavern on Main Street near what is now Center Park, also known as the Town Common or Soldiers and Sailors Memorial Park.

On July 10, 1739, the town of Wareham was incorporated. Text from the official incorporation follows:

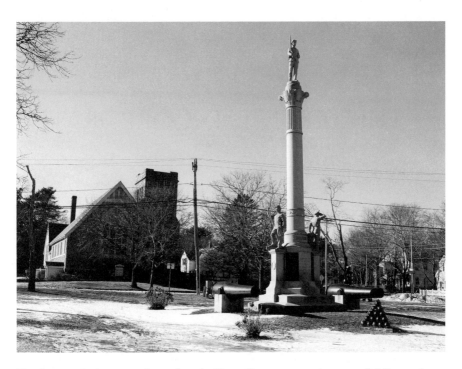

The first meetinghouse was located on the Town Common, now known as Soldiers and Sailors Memorial Park, on Main Street. *Michael J. Vieira.*

Anno Regni Regis Georgii Secundi uodecimo et duotertio.
An Act for dividing the town of Rochester and Plymouth, in the County of Plymouth, and erecting a new Town there by the name of Wareham.

 Whereas, the Inhabitants of the East End of the Town of Rochester, and the Inhabitants of the Plantation called Agawam, being in the Town of Plymouth, by Reason of great Difficulties they labor under have addressed this Court, and vested with all the Powers and Privileges that other Towns in the Province are vested with. For which they have obtained the Consent of the said Towns of Rochester and Plymouth.

 Be it therefore enacted by His Excellency the Governor, Council, and Representatives of the General Court assembled, and by the Authority of the same, that the East End of the Town of Rochester, bounded as followeth, viz: Beginning at the mouth of the Sipecan River, and running up to the River to Mednoe's Bridge: thence as the road now lies to Plymouth till it meets with Middleborough line, being all the lands belonging to the Town of Rochester lying North of said River, and on the East side of said Road, together with the Plantation or Precinct of Agawam aforesaid as described

in their purchase Deed from the Town of Plymouth be and hereby are set off, Constituted, and Erected into a distinct and separate Township by the name of Wareham, and that the Inhabitants of the Lands before described and bounded be and hereby are vested with all the Powers, Privileges and Immunities that the inhabitants of other Towns in this Province are or ought by law to be vested with, Saving that the Privilege of Catching Ellwives be and remain as heretofore.

In 1739, July 6. This Bill having been read thru several times in the House of Representatives passed to be Enacted.
J. Quincy, Spkr.

1739, July 6. This Bill having been read thru several time in Council, passed to be Enacted.
Simon Frost, Dep. Sec'y.

1739, July 10. By His Excellency the Governor. I consent to the Enacting of this Bill.
J. Belcher.

The reason that the town was named Wareham is not known. Although there is a historic market town in the English county of Dorset named Wareham and some of the colonists were originally from that area, there are no definitive records that connect the Massachusetts town with the English town.

THE HERRING HERITAGE

It may be a little fishy, but it is interesting to note that the official papers of incorporation specifically refer to the retention of rights to "Ellwives," or alewives. The arrangement continues today, and the Town's Open Space and Recreation Plan, 2010–17, cites a Woods Hole Research Center report on the fish:

*Each spring alewives (*Alosa pseudobarengus*), blueback herring (*Alosa aestivali*), American shad, and rainbow smelt migrate from the coastal water through the major river systems and several smaller brooks in Wareham to reach fresh water ponds to spawn. Alewives return between*

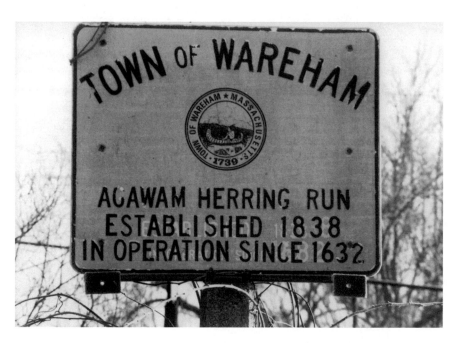

This undated Herring Run sign recalls the history of the little fish and its continued importance to Wareham. *Wareham Free Library.*

> *March and April to spawn and herring return from late April to late May. These anadromous fish return annually to the Weweantic River, Agawam River, Wankinco River, Gibbs Brook, and Red Brook.*

Smelt run primarily up the Weweantic River; however, they also occur in the Agawam River in lesser numbers. Anadromous fish hatch in fresh water, spend their adult lives in salt water and return to fresh water to spawn. Anadromous fish generally use the same route that they followed to the ocean as juveniles to return to spawn in the same location where they were hatched. These fish are important links in both marine and freshwater food webs, and they are important renewable resource to humans. They are recreationally, aesthetically and commercially important.

In the 1700s, alewives were not only widely available but were also an important food source, especially because they could be pickled or smoked. This would provide food year round. The little fish were also used for fertilizer and as bait. As early as 1735, Massachusetts Bay Colony passed laws requiring mill owners to provide passage at their dams for the migrating fish.

More Fish Than Folks

According to the *History of Wareham*, "At the time of its incorporation…it is not known what [Wareham's] population was. At that time, every town containing forty qualified voters, was entitled to a representative." For forty years after its incorporation, the town voted that it wasn't "qualified" and, when needed, sent an "agent" instead of a representative to the general court.

The first town meeting was held on August 6, 1739. Edward Bumpus, "one of the principal inhabitants," was ordered by the general court to call the meeting, at which Bumpus was chosen moderator; Jonathan Hunter, town clerk; Jireh Swift, Jeremiah Bumpus and Jonathan Hunter, selectmen and assessors; Jireh Swift, treasurer; John Bumpus Jr. and Joshua Gibbs, constables; Joseph Gifford, Isaac Hamblin and Jonathan Bumpus, surveyors of highways; Henry Saunders, tithingman; and Ebenezer Perry and John Ellis, fence viewers.

According to early histories, residents in both areas were very vocal at town meetings about their "exclusive rights." The unnamed author of the 1867 history also noted that although incorporated as one town, in fact, from 1739 to 1824, there were two constables—one for the west and one for the Agawam area—as well as two appointed collectors and two sets of tax bills.

The First Meetinghouse

In 1735, prior to the town and church incorporation, land was set aside for a meetinghouse. Thomas Prince, a resident of Cromeset Neck, is reported to have preached from time to time in the early eighteenth century in a meetinghouse that stood near the present Congregational church. There seem to be no records about this first meetinghouse, but Noble Warren Everett records the following actions in the *History of Wareham* that was part of D. Hamilton Hurd's *History of Plymouth County* published in 1884.

A vote was taken on September 10, 1739, "to have the meeting-house they then met in for their meeting-house." This apparently was the usual practice in which the town would take possession of the "oldest or first meeting-house" and keep it in repair for a "town-house." In 1742, Isaac Bump sold the town the land on which the meetinghouse stood, and in 1757, it was voted "to clear the alleys of the meeting-house of chairs and all other incumbrances, and keep them clean."

The old meetinghouse was given to "certain subscribers" to build a new one "on condition that the town keep it in repair and use it for a town house." Hurd's history describes it as follows:

> *The new meeting-house had forty-one square pews on the floor, twelve slip-seats in the centre, appropriated for the use of the aged, whose hearing had become obtuse, strangers, and the respectable poor, and a broad gallery on three sides, with a row of pews in front, and slip-seats back, to accommodate servants, boys, and the common poor. There was much taste displayed in the architecture of the inside of the building, particularly about the pulpit and sounding-board.*
>
> *The exterior of the building resembled most other country meeting-houses of that day, had its round-top porch in front, with three doors, and two flights of stairs leading into the gallery. The body of the house was nearly square, and much too high for its size. This error, no doubt, was committed by taking pattern from some other meeting-house.*
>
> *Wherever one of these old-fashioned churches are seen of the first magnitude, the height well accords with the size, but the smaller ones by preserving the same height, present the appearance of one cube set upon the ground, and a half-cube cut diagonally, whose hypotenuse is about two feet greater than the side of the first cube laid thereon to form the roof. These houses had three times as many windows as was necessary to light the building, set in double rows for the sake of symmetry.*

Once the town was incorporated, a committee was also chosen to search for a minister. It offered the Reverend Rowland Thacher, a Harvard graduate, a £300 settlement and a £100 salary. He was ordained on December 26, 1739, and the First Church of Wareham was established on December 25 of that same year.

For almost one hundred years, what was to become the First Congregational Church of Wareham was the only church in town. Like most towns, Wareham used its meetinghouse, it appears, for services on Sunday and then by the community the rest of the week. Hurd quotes John Trumbull's poem about a Tory squire, MacFingal, to describe this tendency:

> *That house which, loath a rule to break,*
> *Served Heaven but one day in the week;*
> *Open the rest for all supplies*
> *Of news and politics and lies.*

Ebenezer Burgess recalled the early days of the church in a "discourse" delivered in 1861. He stated that there were fifteen men and twenty-eight women who made up the original church membership. He suggested that the number "demonstrates that they had for many years maintained public worship and enjoyed the ministration of Christian ordinances, before they were gathered into a distinct church," and he traced the "stable principles and moral habits" to the Pilgrims of Plymouth.

Reverend Thacher served the congregation until his death on February 18, 1775. At the time of his death, the membership had grown to 145. Josiah Cotton was the second pastor but was "dismissed" in 1779 and left the ministry. For two or three years, the church was without a permanent minister. In 1782, Noble Warren Everett was ordained pastor. He died in office on December 30, 1819.

The town continued to grow and worked to meet the needs of its residents. Like many towns in Massachusetts, Wareham began electing "deer reeves" once the town was established. Their primary job was to enforce the colonial law established in 1698 that prohibited killing of deer between January 1 and August 1. It was modified in 1763 to begin on December 21. Among the early punishments recorded in a Worcester court record of 1748 was a fifty-shilling fine, with half being paid to the king and half going to the informers. Wareham had a deer reeve from 1739 until 1829, when reports indicate most of the deer were gone from the region.

A CONNECTICUT COLONY

Shortly after Wareham was incorporated, Sibyl Jerome reported in his history that the town sent "a colony" of more than one hundred to Sharon, Connecticut. According to the Sharon Historical Society, Cornelius Hamlin of Wareham is listed as one of the first settlers of the town, which was incorporated in 1738.

Joshua Gibbs, also of Wareham, bought what might be the oldest house in town (99 Main Street) and ninety acres for "very little money." He sold it in 1748 for almost three times the amount.

It appears that many others from the Wareham and Rochester area also moved to Sharon in the 1740s. According to the Doty-Doten family history:

> *Almost every family at Wareham seems to be represented by a member in the new settlements while of some, various members or whole families removed. Thus we find numerous representatives of the Hamlin, Blackmer, Bumpus, Jackson, Delano and other Wareham families at Sharon, while of the Dotys, Joseph Doty, uncle of Capt. Samuel Doty was probably accompanied by at least one brother, Simeon Doty.*

It appears that in some cases, like many settlers, the Wareham families saw an opportunity in Connecticut and took advantage of it. Gibbs evidently made money in real estate, and Captain Doty was listed as a laborer in Wareham who went on to become a mariner; a surveyor, whose work included laying out Main Street in Sharon; and an active community member in real estate and business, including an ironworks. Captain Doty's father was a smith in Wareham, so the connection between ironworks may explain some of the interaction between the towns.

THE TOWN GROWS

In 1741, the first public school was established in the town. Though no records indicate its location, a one-room schoolhouse was located near the Stockton Road location. It was later moved to Great Neck Road near Crooked River Road and then moved again by the Wareham Historical Society to its current location on Main Street.

In 1765, the population of Wareham grew to 503 residents. Some of these were Acadians, or French neutrals, who settled in town in the late 1750s, according to the Massachusetts Historical Society's reconnaissance survey.

As the town grew, the Bumpus and Fearing families emerged as two major players in the region. In a way, they represented the two very different colonies that merged in forming Wareham.

The Bumpus family was related to John and Priscilla Alden, two immigrants from the *Mayflower*. Edward Bompasse arrived in the New World in 1621 on the *Fortune*. They moved from Plymouth Colony and became known as the Bumps. They were a hardworking lot, making their money by purchasing large tracts of land, cutting timber and converting it to lumber. They also built dams and opened mills along the rivers.

John Fearing arrived from England and settled in Hingham in 1638. Like many in the Massachusetts Bay Colony, the Fearings were well connected to

the king of England. His son Israel was a justice of the peace, and his title of squire indicates that he was expected to represent England in the New World. Israel Fearing, Esquire, owned more than five thousand acres in 1715 and donated the land for the town burial ground in 1746. He also provided a gate, which he noted in the deed that he was not responsible to maintain.

The two families undoubtedly did a great deal of business together, and when Isaac Bump was sixty-six, in 1747, he sold all of his properties to Israel Fearing for £2,000. None of the properties left more of a lasting impression on the town than Bump's small home, which became the Fearing Tavern and lasted into the twenty-first century as Wareham's oldest house.

When Israel Fearing died in 1754, he willed the house to his son Benjamin. By then, the home had already served as a public meeting space until the town meetinghouse was built. At some point, what was described in Isaac Fearing's will as a "leanter" was added to the home. This served as a tavern where Hannah, the widow of Benjamin's brother Israel Jr., was given "liberty to bake and wash."

When war was declared between the French and English in 1756, its effects were felt throughout North America, primarily through what has been called the French and Indian War, or the Anglo-French rivalry. It involved the colonies of British America and New France from Virginia to Nova Scotia.

The townspeople of Wareham "lent their aid," according to Everett's history:

> *John Bates, Barnabas Bates, Jabez Besse, Henry Sanders, Oliver Norris, Joshua Besse, Ebenezer Chubbuck, Joseph Besse, and Samuel Besse went to Cape Breton and assisted in the taking of Louisbourg, some in the land forces and some in the navy, and Samuel Besse lost his life in the expedition. About the same time Nathaniel Besse, Grershom Morse, Newbury Morse, Einathan Sampson, and Nathaniel Chubbuck went into the Northern army, and were employed in taking Canada. Also, there were four Indians who resided in this town, named Jo. Joseph, Sol. Joseph, Jabez Wickett, and Webquish, who went and fought against the hostile Indians on the Canada frontier. Webquish, who died about the year 1810, said he was present upon the plains of Abraham when Gen. Wolfe fell, and saw the city of Quebec taken. The above-named Nathaniel Chubbuck was in the English army at the time they were defeated near the city of Carthagena, in South America, in 1741, and also at the taking of Havana, in Cuba, in 1763.*

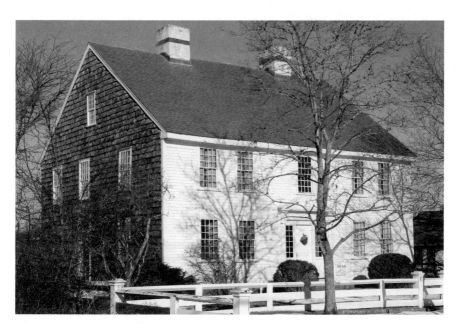

Now owned by the Wareham Historical Society, the Fearing Tavern remains an important structure in town. *Michael J. Vieira.*

The war ended in 1763, and in 1765, Benjamin Fearing added a new section with a "grand entrance" facing south and a taproom on the west to the Fearing Tavern. The addition wrapped around the 1690s structure, not only saving it but also providing a taproom for the tavern. The bar, with its original wooden grill, remains intact. The addition also provided space for what is now called the West Parlor, its high ceilings a marked contrast to the low ceilings in the original house. A small room with a window facing east was the first town post office, which was in operation from about 1739 to 1800.

The roof was raised over the entire structure, creating a large attic where the hand-hewn beams remain visible. Four large rooms in total were added to the seventy-five-year-old home, and the old lean-to was incorporated into the tavern room. Three flights of stairs provide access from the first floor to the attic. According to a brief history of the Fearing Tavern:

> *Some believe the stairs were built to provide access to the roof in case of fire while others have suggested that small cannon may have been hauled up over them and aimed for the roof. There is an iron hook in the roof to support this later theory.*

Benjamin's brother John inherited the farm and Fearing Hill, where he later built a home. He succeeded his father as justice of the peace and also added the title of squire to his name. He often held court in the tavern and could charge fines or sentence imprisonment in the stocks or lashings at the whipping post, both of which were located on the grounds of the Fearing Tavern. Other brothers, Noah and David, received a substantial inheritance from Israel as well.

TAXATION WITHOUT REPRESENTATION

Like many other colonial towns, the town of Wareham was impacted by the increasing taxes being imposed by the British Crown. In 1773, a town meeting moderated by Captain Josiah Carver was held on January 18 and continued to February 8 in order to give a committee composed of David Nye, Barnabas Bates and Benjamin Briggs an opportunity to look into the grievances outlined in a letter from Boston, which drew attention to the acts of Parliament requiring "a tribute or tax from the people of this Province."

Like many other residents of the colonies, the people of Wareham were hoping for peaceful solution, but their words clearly indicated that they felt this was taxation without representation, a theme that would grow more popular in the colonies over the next couple of years. The Wareham resolution stated:

1. Resolved, That by the charter of this Province we are entitled to all the privileges and immunities of the natural born subjects of Great Britain, therefore,

2. Resolved, That the raising of a revenue on the people by a legislative authority where they have no right in the election, or returning of any of the members, is a great grievance, as we are thereby taxed by other than our own representatives.

3. Resolved, That the extensive power given to the com-missioners of his Majesty's customs in America is a grievance.

4. Resolved, That the affixing salaries on the judges of the Supreme Court of judicature, within the province, out of the aforesaid revenue, is a grievance, as our lives and property are so nearly concerned in the decision of judges who hold their places during pleasure, and are entirely dependent on the Crown for their support.

5. Resolved, That the [sic] extending the power of the courts of Vice-Admiralty so as that in many things it destroys the privilege of, the trials by juries, is an extreme grievance and in particular that remarkable distinction made between the subjects in Great Britain and those in these Colonies, in sundry acts of Parliament in which the property of the colonists is given up to the determination of one single judge of admiralty whereby the same act the subject in Great Britain is tried in his Majesty's court of record.

6. Resolved, That we will freely join with the town of Boston, or any or all the other towns in this Province, to take any legal measures to obtain a removal of the above grievance in a constitutional manner.

7. Resolved, That whereas we are not in the capacity to send a representative to represent us in the general assembly of the Province, we desire the committee of correspondence of the town of Boston to use their influence in that constitutional body, that they may petition our most gracious sovereign for a removal of the above-said grievances, or that such method for the recovery of our ancient and invaluable privileges as in their wisdom may appear most conducive to the common good of the Province.

8. Resolved, That the thanks of this town be returned to the inhabitants of the town of Boston for their letter of correspondence, and the care they have taken to acquaint the Province in general, and us in particular, of the divers measures that have been, and still are, taken to deprive us of the privileges enjoyed by the subjects of the same Prince in Great Britain.

9. Resolved, That if any person for the sake of any post of honor, or any private advantage whatsoever, shall basely desert the common cause of British Freedom, and endeavor to hinder or obstruct our thus recovering our ancient and invaluable privileges, he shall be deemed an enemy to his country, and shall be treated by us with that neglect and contempt that his behavior deserves.

Lastly, That these resolves be recorded in the town's book of records, and that the town clerk transmit an attested copy of the same under his hand to the aforesaid committee of correspondence for the town of Boston.

By January 16, 1775, the people of Wareham took further action, providing one shilling and four pence per week for any Minutemen. They also refused to pay any province or county tax under the king's authority and "to pay the province tax already made to Dr. Andrew Mackie, with instructions that he keep it until the town should otherwise order."

By March, the town had voted to purchase six guns for town use and directed Nathan Bassett to repair the other guns and make bayonets to fit them.

But like many towns, Wareham had residents who were fiercely in favor of independence and others who remained loyal. At times, they lived under the same roof. Local history recalls the story of an Israel Fearing, probably Israel Jr. born in 1723. When word arrived in Wareham of the Battle of Lexington on April 19, 1775, Israel put on his uniform and rushed to lead his men in the Marshfield Company. His wife, the former Lucy Bourne, was an unwavering Loyalist. She tried, unsuccessfully, to stop him from leaving and, in a final attempt, grabbed onto his coat. He broke away, leaving a piece of his uniform in her hands. The Revolutionary War was on.

THE WAR YEARS

Wareham was spared much involvement in the King Philip and French and Indian Wars, but the War for Independence impacted the community. Early records indicated that 86 men from the town served in the militia and 13 gave up their lives. More recent information seems to show that a total of 131 Wareham residents fought for independence.

Much of the information about the war comes from Noble Warren Everett's history. He reported that when word arrived about the fighting in Lexington, a militia company led by Captain Noah Fearing and Lieutenant John Gibbs responded. The two officers were accompanied by two noncommissioned officers, a drummer and twelve privates. At about the same time, a report arrived that the British had landed at Marshfield. Captain Israel Fearing, Lieutenant Ebenezer Chubbuck, four noncommissioned officers, a drummer and a fifer led a contingent of twenty-nine privates to help defend that town.

When they reached Plymouth, they learned that the King's troops had left Marshfield and were heading to Boston. The Wareham men returned home. The town, which by now numbered 711, voted on January 16, 1776, to pay twenty-one pounds, five shillings and four pence to each of those who responded to the call. Those who did not respond to the alarm were not to receive any pay.

Wareham residents also played a role in what some consider to be the first clash of the British and colonists on the sea. After the Battle of Lexington, Boston was under siege, and General Thomas Gage sent his warships south looking for food supplies. One of these, the *Falcon*, commandeered two

sloops in Vineyard Sound to use as decoys and headed toward New Bedford. An unknown rider from Wareham brought the information of the British plan to New Bedford. Twenty-five men in a small vessel intercepted the two sloops on May 14 and 15, 1775. The *Falcon* abandoned its plan.

Also in 1775, a call was sent to the colonies looking for enlistments. In total, thirty-six Wareham men responded during that first year of the war. Everett's history provides the names of those who served, which includes many of the names of the earliest town families. Ebenezer Chubbuck, Samuel Besse, Nathan Bassett, Barnabas Bates, David Saunders, Barnabas Bumpus, Judah Swift and Daniel Perry went to Roxbury and served a term of two months. At about the same time, Joseph Bosworth, John Besse, Joshua Besse, Joseph Saunders, William Conant, Joseph Bumpus, Consider Sturtevant, Ephraim Norris, Rufus Perry, John Bourne, Benjamin Russell, Samuel Morse, Caleb Burgess, Barnabas Bates, Joseph Bates, Thomas Bates, Samuel Bates and Jabez Nye were stationed along the shore in Wareham. They enlisted for a term of six months and were paid by the state. During their enlistments, they were rowed in two whaleboats to respond to an alarm from Naushon.

Serving in the army for eight months near Boston during this same period were Edward Sparrow, Lieutenant Willard Swift, Lemuel Caswell, John Lathrop, Calvin Howard, Samuel Phillips, Samuel Barrows, Benjamin Chubbuck and William Thorn. Nathan Savery and John Bourne went to the Finger Lakes area of New York and assisted in taking Ticonderoga and Crown Point.

When a call went out in 1776 for one-year reenlistments, Edward Sparrow, Josiah Harlow, Willard Swift, Lemuel Caswell, Samuel Barrows, Samuel Phillips, William Pierce, Arthur Hathaway, William Thorn, Jesse Swift, Benjamin Gibbs, Caleb Burgess, Benjamin Burgess, William Bumpus, Benjamin Swift, John Gait, Solomon Hitchman and Rufus Perry joined the army near Boston. When the British were evacuated from there, they went to New York.

Wareham established a Committee of Correspondence, Inspection and Safety on March 18, 1776. John Fearing, Andrew Mackie, Israel Fearing, Joshua Gibbs and Prince Burgess voted to pay for five pickaxes, eleven spades and six narrow axes for the army.

In June, there was another call for men to go to New York, and Joseph Bates, Perez Briggs, William Hunt, Joseph Bosworth, Nathaniel Burgess, Benjamin Swift and Benjamin Chubbuck enlisted for the five months in response to the call.

THE LINCOLN DIARY

Among the firsthand reports that survived from the war is the diary of Captain Rufus Lincoln of Wareham. Records show he served as a corporal at the Lexington alarm and, in 1777, raised and equipped a company for the defense of Fort Ticonderoga. He also served in the Burgoyne Campaign and at the Battle of White Marsh. He was captured at Valley Forge and was held until 1781. He died in 1839 at the age of ninety in the house he bought in Wareham in 1779.

In his first entry, he describes a battle on June 28, 1776, followed by a brief note about a historic event. Lincoln often employs not only archaic but often creative spelling:

> *General Clinton and Sir Peter Parker Atempt to pass by Forrt Moultra up to Charles Town after being there some days and are Repulsed Sir Peter Receiv d A wound which Ruined his Britches of which wound he Afterwards died it was Said the Brittishe had About 300 killed and many wounded one of their Vessals called the* Acteon *was got A ground and was Evacuated and blown up A 26 gun Brig Americans had 11 men killed in the Fort and 12 wounded most of them mortally.*
> *July 4, 1776. The Declaration of Indence.* [Independence]
> *The British troops evacuate Boston and go to Halifax.*

Lincoln goes on to give detailed reports of the action at Lake Champlain and of Fort Washington being taken by the British. He lists all the men in his company and tracks the number of troops, the deaths and the injuries of many famous battles.

Beginning in 1777, Congress called for men who were willing to serve in the Continental army for three years. Joseph Bates, Joseph Saunders, William Conant, Jonathan Saunders, Lot Sturtevant, David Burgess, Nathan Sturtevant, Solomon Hitchman, Moses Sturtevant, James Bumpus, Amaziah King, Reuben Maxim, Joseph Bumpus and William Parkerson enlisted and marched against Burgoyne's army as a result of the call.

At about the same time, the state called for two months' men to go to Rhode Island. Silas Besse, Hallet Briggs, Benjamin Bourne, Joseph Swift, John Winslow and Asa Bumpus responded to the call and were stationed near Howland's Ferry. They were soon joined in Rhode Island by Prince Burgess, Ebenezer Burgess and Heman Sturtevant and were in the battle fought by General Sullivan at the south end of the island. Everett reported

that they all fought bravely. In August, nearly every man of the militia went against Newport on a secret expedition that did not succeed, and they soon returned.

On March 26, 1777, Wareham chose new committeemen. They were Jeremiah Bumpus, Ebenezer Chubbuck, Israel Fearing, Edward Sparrow and Barnabas Bates Jr. On September 29, the committee approved spending thirty-three pounds to pay for one hundred pounds of powder. In November, another one hundred pounds was approved for "supplying the families of the Continental soldiers, and [a] committee [was chosen] to provide such articles as they should need." Everett explained the significance:

> *This vote shows that those who stayed at home* [on] *that trying day did not forget the widow*[ed] *and the fatherless. The property of the rich went to feed the poor by vote, and not by the liberality or narrowness of each individual heart. And there were some who did more than vote. Silvanus Bourne, Esq., of this town, long since deceased, once gave the following incident: "An aged lady by the name of Reed but a few days since told me she was married in the year 1775. The next year her husband went into the army, leaving her young and inexperienced, with an infant upon her bosom, to manage the domestic affairs indoors and out through a long and bitter-cold winter; and when she heard from her husband it was from the battle-field, with the battle bravely fought, but not finished. At length he returned; another winter approaching, he was drafted again, and through her entreaties he was prevailed upon to hire a substitute. In addition to the pay agreed upon, he told the man that when he returned he would assist him in building a house. The man was killed in the battle at the taking of Burgoyne; but, said she, his poor widow did not go houseless, for my husband built it, and made her comfortable as long as she lived."*

General John Burgoyne surrendered his army at Saratoga in what most consider a turning point of the war in 1777. Wareham's Barnabas Bates, Silas Besse, Silas Fearing, John Gait, David Perry, Jabez Besse and Nathan Norris went to Boston on a three months' tour to guard the prisoners.

In December 1777, Rufus Lincoln was at White Marsh, Pennsylvania, better known as Valley Forge. He says he was building huts and went on a scouting or foraging mission with some of the men. At Daby, which is now part of Philadelphia, he was captured.

On the way to New York, he "spoke sharply to a Hessian," who lunged at him with a bayonet, hitting him in the chest, but the blade was blocked

by a book or papers from doing any harm. He remained a prisoner of war in Long Island, New York, but was "paroled" to live at Petrus Ammerman's house in King's County, removed to another location in 1778 and exchanged in 1781.

In September 1778, the British burned ships at New Bedford, and the militia of this town turned out generally at the alarm. Major Israel Fearing of Wareham and his militia, who were heading from New Bedford to Sconticut Neck, are credited with saving Fairhaven village from destruction. Also in 1778, there were two alarms at Falmouth. The Wareham militia responded, but the enemy was not found there. Again, in October 1778, the townspeople voted to raise money to pay for soldiers' clothing and chose a committee to supply the soldiers' families the ensuing year.

Wareham leaders were also concerned about protecting their own town and, on January 11, 1779, voted to "raise by tax 184 pounds in the west end of the town" to pay Andrew Sturtevant and Asa Bumpus as "nine-months men." They also voted to fund soldiers in future by a town tax, and a committee was chosen to hire them for the town. The Committee of Correspondence, Inspection and Safety, consisting of John Fearing, Andrew Mackie, Samuel Savery, Barnabas Bates and Prince Burgess, voted to sell the nine guns that came from Boston. They were sold for $380.50.

Dollars or Pence

The reference to dollars in town reports related to the war appears to be the first mention of the currency. Although the Massachusetts Bay Colony was the first to issue its own colonial currency in 1690, most colonies had paper currency, usually based on the Spanish dollar, but colonial notes were also issued using British pounds, shillings and pence. It's not clear if this reference is to Spanish dollars, which were widely circulated, or to Continental currency, which the Continental Congress began issuing in 1775 and ranged from bills for one-sixth of a dollar to an eighty-dollar note.

The distinction is spelled out on June 20, 1780, when the town voted that

> *the six months' men, now sent into service, be hired by a tax, and that each man have sixty-nine silver dollars as a bounty, and one hundred and thirty paper dollars per man mileage money. Voted to eleven three months' men forty silver dollars per man, and one hundred paper dollars*

per month; and Capt. John Gibbs, William Conant, Thomas Bates, Silas Bosse, Lot Thatcher, Lot Bumpus, Seth Stevens, Isaac Stevens, George Glover, Benjamin Benson, George Gurney, and Thomas Barrows were the captain and eleven men mentioned in the last vote. These men went to Rhode Island.

During the rest of the war, the town of Wareham would continue to show its support not just for the military effort but also for those at home. In the fall of 1780, the town voted to raise eighty-six pounds and seventeen shillings of "hard money" and approved $280 "hard money" to pay for beef to be sent to the army. In 1781, it also voted to pay for 9,146 pounds of beef to be sent to the Continental army and 400 pounds of beef for soldiers' families.

In order to raise funds to pay soldiers, Wareham approved having a lottery on January 6, 1781. Everett explains:

This last vote shows to what extremity the town was pushed to raise the funds necessary to carry on the war; but they shrunk not back; when the people had become so poor that money could not be raised by tax, they sought other expedients and found them.

It appears the lottery was successful. In September of that same year, the town voted to spend £21 for two five-month soldiers, £72 for four three-month soldiers and £126 for seven three-year soldiers. More funds were approved in 1782 and 1783, but those were to compensate soldiers already in the army and not to compensate new enlistees.

WAREHAM AT SEA

In addition to their contributions to the battles on land, Wareham residents also supported the fighting at sea. Captain Barzillai Besse, John Gibbs and Nathan Bassett were commissioned by the Massachusetts Bay Colony to attack the British. According to Everett's history, Besse, Gibbs and others joined Captain Joseph Dimmick of Falmouth on a wooden sloop that was "borrowed" for the occasion.

They started running the sloop down toward the enemy's vessel, which was mounted with six swivel guns, or small cannons. Dimmick was ordered to strike, but instead, he appeared to show submission. However, as he ran

under the stern, Dimmick put his bowsprit over the enemy's taffrail, the usually ornate tail piece of a boat. His men jumped on board, killed the English captain and took the vessel in a few minutes.

A ten-gun sloop named the *Hancock*, owned by John Carver, Nathan Bassett and others, was also fitted out as a privateer from this place and was commanded by James Southard. During its first cruise to the West Indies, it captured two vessels, and on the second cruise, it took two brigs and brought them back to Wareham.

Wareham also suffered some losses at sea, including the schooner *Lion*, which was captured while coming from the West Indies with a load of salt; the schooner *Desire*, which was headed to Brazil; and a sloop that was built for a privateer. The sloop completed one successful war mission but was sent after to Turk's Island for salt. It was taken when returning.

During the conflict, Rufus Lincoln kept careful lists. He recorded supplies, gathered information from British and American reports about the numbers of dead and injured and maintained his own "Descriptive List" of fifty-one noncommissioned officers and soldiers in his company of the Seventh Massachusetts Regiment. It provides height, hair and skin color, as well as where they lived and other information.

What the record shows is that Captain Lincoln's men not only came from several different counties, which seems to indicate that the recruits were getting scarcer as the war went on, but also that his ranks included at least five African Americans. As the American Revolution Center timeline suggests:

> *By this stage in the conflict, many military and political leaders who had earlier resisted the enlistment of enslaved and free African Americans changed their opinions. Black soldiers had performed admirably in battle, and in many states they provided a much needed source of manpower to keep the regiments full. Historians estimate that more than five thousand African Americans enlisted in the Continental Army, most serving in integrated units like Captain Lincoln's Company.*

A NEW BEGINNING

In 1783, the Treaty of Paris officially ended the war. Along the road to independence, thirteen men from Wareham gave their lives. They were Samuel Barrows, Samuel Besse, John Bourne, Caleb Burgess, John Lathrop,

William Parkerson, Rufus Perry, Samuel Phillips, Jonathan Saunders, Moses Sturtevant, Nathan Sturtevant, Benjamin Swift and William Thorn.

Throughout the Revolution and before, there was regular mail service delivered by horseback riders to the area. According to a paper presented at the Old Dartmouth Historical Society in 1921, mail went to Boston and returned twice a week. Thomas Terry rode the post to Rochester and Wareham in 1797.

Also in 1797, the same paper notes, the first stage line was operated by Abraham Russell of New Bedford, and letters and packages were left at taverns like Sproats and Westons in Middleborough. From there, they likely were delivered or picked up for those in Wareham.

Books were expensive in the eighteenth century, which is why Benjamin Franklin and others opened the first public library in the United States. Wareham wasn't far behind. In 1798, the Wareham Social Library opened. This lending library had 118 titles.

During the Revolution, salt was in great demand, and residents of many ocean communities would boil water to harvest it. By the early 1800s, saltworks used evaporation to yield the product. Many were located in Onset and Wareham.

Shipbuilding was also flourishing at the Narrows after the war, and some Wareham-built boats of the period carried the names *Pocahontas*, *Jubilee*, *Wareham*, *Kutusoff*, *George Washington*, *Republic* and others. Rochester's bicentennial report in 1879 said that although the boats received great attention for their size at the time, by the late 1800s, they would have been considered "long boats."

Captain Kendrick's Voyage

Perhaps the most important Wareham resident to sail a ship was Captain John Kendrick. Captain Kendrick not only is credited with discovering the Columbia River on the Washington-Oregon border but is also said to be the first American to meet with the Japanese and carry the American flag around the world.

During Kendrick's early career, he sailed a whaling brig to the grounds off Cape Verde and was almost seized by the Spanish in the Gulf of Mexico. Family tradition says that he took part in the Boston Tea Party. During the Revolutionary War, he captained the *Fanny* with a crew called "the Boston Men" and captured ships filled with sugar and rum from Jamaica, which

resulted in an international incident involving the French, Benjamin Franklin and Congress. It also ended with Kendrick making enough money to buy a home in Wareham, now the Kendrick Maritime Museum, as well as a wharf and store. Some say he even built a school.

After the war, the U.S. government wanted to open a gateway in the Pacific, and Kendrick was hired to follow the route of James Cook's third voyage to the Hawaiian Islands. Kendrick sailed the *Columbia Rediviva*, a three-masted brig, and Rhode Island resident Robert Gray captained the *Lady Washington*, a coastal sloop.

They sailed across the Atlantic to Cape Verde, then crossed back to the South American coast and headed south along it, stopping at the Falklands for water. Despite brutal storms and tension among the crew members, the ships made it around Cape Horn, after first being separated by storms. After encounters with the Spanish, an epidemic of scurvy and other challenges, the two ships finally reunited in Nootka, now Vancouver Island.

After a successful trading mission and much work on the two ships, including adding a second mast to the *Washington*, Kendrick switched ships. Gray took the *Columbia* to Canton and then returned home to Boston. Gray

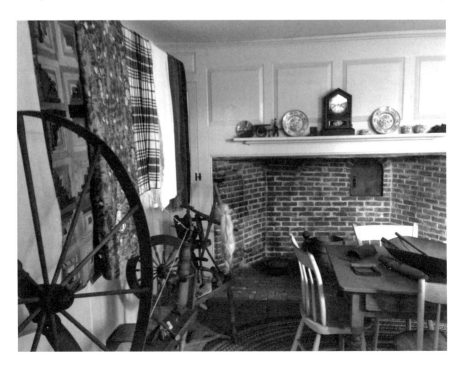

Captain John Kendrick purchased his home in 1778. It currently serves as the Kendrick Museum, operated by the Wareham Historical Society. *Michael J. Vieira.*

later took a second voyage and explored the Columbia River, which was named after the first nonindigenous vessel to enter it.

Kendrick sailed around Vancouver, and so some say he was the first to identify it as an island. After more trading, and allegedly brutal dealings with the native people, Kendrick sailed to Hawaii, then called the Sandwich Islands, and became the first American to use Pearl Harbor as a naval base. Now fully provisioned, Kendrick went to Macau and continued to Japan, which is how the Wareham resident was the first American to meet the Japanese.

From Japan, Kendrick engaged in a battle on Queen Charlotte's Island and then arrived in Fairhaven, now Honolulu, Hawaii, during a civil war on the island. He joined in the fray, and Kendrick's side was victorious. To celebrate, he fired a cannon salute from the ship and went to his cabin. A British ship answered the salute, but the third salvo misfired and hit Captain Kendrick's cabin. He died from the shot fired in his honor on December 7, 1794.

His exploits are remembered in the museum located in his former home and in books, including Scott Ridley's *Morning of Fire*, from which some of this information was taken. Some say he was Hawaii's shortest-living hero.

THE ATTACK OF THE NIMROD

After the Revolution, Wareham grew in terms of population and businesses, but when the War of 1812 commenced, many Wareham men ran small vessels as far away as New York. Several of their ships were taken by the British and held for ransom. One of these, the *Polly*, is recalled for its role in the most famous of the local battles involving the HMS *Nimrod*.

When the *Polly* was taken off the shores of Westport, its captain, Captain Barrows, returned to Wareham to get the $200 it was being held ransom for. He left Moses Bumpus and James Miller with the British, but while he was away, men from Westport retook the sloop. Bumpus and Miller were left on the *Nimrod*. Whether willingly or not, the sailors may have helped the British head up the bay to West's Island, where they took Samuel Besse by force to pilot the brig up the bay.

On June 13, 1814, Ebenezer Bourne spotted the *Nimrod* off Mattapoisett and took his boat to warn the people of Wareham. Arriving at the Narrows, he spread the alarm through the town, and town selectmen ordered Major William Barrows to assemble the men and prepare their guns. The town leaders would get ammunition from the town stores kept

The Crocker-Fleming House was moved to its current location in 1796. One of its owners, Wadsworth Crocker, was keeper of the ammunition supplies during the War of 1812. *Original sketch used with permission of Pamela Rainey Enos, 1988.*

by Wadsworth Crocker, Esq. A rider then headed to the public house kept by Captain Israel Fearing and told him to also call out the men of Agawam Village.

While the men were assembling, William Fearing, Esq., and Jonathan Reed told the major to hide the weapons because they had made a treaty with the British to spare private property. The Wareham men hid the guns under Captain Jeremiah Bumpus's porch and left the powder keg nearby.

When the British arrived in the channel, they put up a white flag and sent six barges to the lower wharf, landing where Narrows Bridge is today. About two hundred British soldiers paraded onto the land and sent a sentinel to the back of the village with orders to let no citizen pass. Although Fearing and Reed approached with a white handkerchief to remind the British about the treaty, they continued their march up the street, stationing sentries along the way, including near the cotton factory.

The British commander said he was looking for ships and men involved in privateering and would not destroy private or town property. He did want to know what ships and property belonged to the Town of Falmouth.

When Barker Crocker, Esq., of West Barnstable arrived, the commanding officer ordered him off his "spirited horse." When the British soldier tried to mount the horse, it reared, and the soldier fell to the ground to the great amusement of the people nearby. After this, the British set fire to the factory, but the flames were quickly extinguished. The British took arms and powder from the Bumpus house after threatening to burn the house down if they didn't get the town stores.

Four schooners from Falmouth had entered the port for safety. They were set on fire by the British. Other British soldiers went to William Fearing's store and then down to the shipyard in his front yard, where they burned a nearly finished new brig. They also tried to burn a brig, a ship and five sloops. These fires were put out but caused considerable damage. To prevent being shot at, the British took hostages and said they would kill them if any gun were fired.

Captain Israel Fearing assembled twelve men on the opposite side of the Narrows and was ready to fight, but he held back because of the treaty and the hostages. The British left the hostages on Cromeset Point and departed without further incident. After firing some celebratory shots, the British gave three cheers and headed back to the *Nimrod*.

As the brig left, Besse was put out on West's Island and Bumpus and Miller at North Falmouth. Besse was arrested and held before a magistrate in New Bedford, where he was acquitted. Miller and Bumpus were examined and put in prison for three months before being acquitted as well. Both sailed on board a privateer, where Miller lost a leg from a cannonball and Bumpus was killed in action.

Benjamin Bourne and Benjamin Fearing sent the following report to the *New Bedford Mercury* on June 14, 1814. It was read as part of the town's 200th anniversary historical pageant on July 10, 1939:

> *Yesterday morning we were informed of the approach of the enemy, and at about 11 o'clock a.m. they landed at the village called the Narrows with a flag. There were six brages* [sic] *containing two hundred and twenty men. They demanded (before the proper authority could arrive) all the public property; and declared that in case they were molested, every home within their reach should be consumed.*
>
> *We were not prepared to make any opposition, and promised not to. To prevent a violation on our part, they detained a number of men and boys as prisoners for their own security; declaring that if any of their men were injured, they should be put to immediate death. Having stationed sentries*

back of the village, they proceeded to fire the vessels and cotton manufactory. Twelve vessels were fired, five of which were totally destroyed; the remaining ones were extinguished after the enemy department. The cotton manufactory was also extinguished.

Damage estimated at 20,000 dollars. It is supposed that the enemy came from the Nimrod *brig, and* Superb 74.

After the British left, trenches were dug near the channel of the river at the Narrows village, but the enemy didn't return. Twelve Wareham men did travel to Newport, Rhode Island, in the fall of 1814. They received wages and served in a corps called "Sea Fencibles." Wareham's Joseph Saunders also fought in the regular army and was killed in the Battle of New Orleans in January 1815. The war ended on February 18, 1815.

THE INDUSTRIAL REVOLUTION

The Industrial Revolution made a tremendous impact on Wareham. In some industries, it was fairly subtle. For example, salt production moved from boiling sea water to evaporating it. This process consisted of putting the water into large wooden vats and allowing evaporation to occur. Portable roofs were often used to protect the saltworks from rain and dew.

From 1775 to 1825, salt pans in Wareham produced great quantities of the natural resource. Most of the saltworks were located between Nobska Point and Onset. Local tradition recalls that the early name for Onset was "Old Pan," which probably was a reference to the evaporation pans used in manufacturing salt.

The Fearing family was involved in the salt production, and Raymond Rider's history recalls saltworks located at Nobska Point, Little Harbor, Griffin's Field, Tom's Narrows, Henry's Creek, Old Pan, the east and west sides of Muddy Cove and other places along the shores of Wareham.

In his history of Fearing Tavern, Rider described the early process of producing salt. Sea water was boiled in large iron kettles set in stone or brick. These fairly permanent structures would yield 30 to 40 bushels of salt a week. By operating six months a year, the output of all the saltworks reached an estimated 8,140 bushels a year, and the salt sold for one dollar a bushel.

In 1806–07, Rider continued, large flat surfaces of wood were built to hold the sea water. The sun would evaporate the water. Asa Swift and Nathan Doty built 1,500 feet of open vats (Rider explains that a foot of saltworks was actually 10 feet square), and Hallet Swift built 1,000 feet at Pigs Point.

By the early 1820s, Aborn Gibbs had built 100 feet; Stephen Swift, 500 feet; Peter Smith, 1,000 feet; Ichabod Leonard, 2,000 feet; and Benjamin Fearing and Stephen Gibbs, 1,000 feet.

In the early nineteenth century, these vast white saltworks dotted the landscape of Wareham. But by 1911, no traces of the industry remained in town.

Wood Rules

Shipbuilding also continued to be a dominant local industry until about 1847. A lack of timber and the shallowness of the Wankinco River are cited as reasons for the decline. In its heyday, Wareham shipbuilding produced not only some large ships but also smaller vessels for coastal trade, whaling and fishing.

There also were other small wood-based mills, such as stave mills, which specialized in the board needed for kegs and other barrels. Seth Tobey operated one near the Wewantic River. The 1867 *History of Wareham* singles out Lewis Kenney, who, in 1829, introduced the first machinery for sawing the staves. In addition to the cylinder saw, for which he held the patent, he also made other improvements to the stave and nail cask industry, including inventing a machine to shape them and another to shave them with precision.

Although long forgotten, the workers of West Wareham also made clay smoking pipes. An article in the October 5, 1872 edition of the *Stoughton Sentinel* said that the factory made about four thousand a day.

By the early nineteenth century, Wareham had grown from under one thousand to nearly two thousand residents, according to the Wareham Preservation Plan. Most residential development was concentrated in the town center along Elm, Main and High Streets, but there were also cottages and worker housing being built near the mills for those who worked there.

The growth of industry also resulted in the need for improved roads, as Lynda Ames noted in her *GateHouse* interview. She explained that by the 1800s, the main road from Marion to Wareham Village continued to the wharves. At the time, a rope ferry was used to bring wagons and people across the Narrows portion of the Wareham River.

Around this time, the Fearing and Bumpus families owned Pine Point, and Sandwich Road provided access to the area. Pine Point became known as Oakdale and, for a time, was an exclusive area, according to Ames. Later, Cape Verdean families established a small community in Oakdale.

WATER WORKS

With its easy access to water power, Wareham was a natural spot to locate mills driven by water. Among the earliest were the sawmills and gristmills operated by the first settlers, but by the 1800s, cotton and paper mills had been established to harness the power of the rivers.

Many centuries after Isaac Bump's death, a sign reading, "Isaac Bump the miller lived here," still hangs on what is known as the Fearing Tavern. By the end of the 1600s, his gristmill was located at Bump Brook, now Rose Brook, and he reportedly had another on the Wankinco River and possibly a third on Rose Brook Mill. Gristmills remained important and operating into the 1800s.

Reverend Noble Warren Everett is credited with operating a fulling mill at Wareham Center. "Fulling" involves cleaning cloth by pounding it with wooden hammers, which, at the mill, were powered by a water wheel. Originally, "fullers" or "walkers" stepped on the cloth in a water tank, but by the 1300s in Europe, the process of using water power replaced the manual process. Either way, the technique not only cleans the cloth but also makes it into a denser fabric.

In 1812, the first cotton mill was built near the fulling mill. This is the mill that was partially burned by the British during the attack on Wareham in the War of 1812 and is located near the Tremont Nail Factory. At least two

This view of the river below Parker Mill was captured in a postcard sent in 1908. Wareham's plentiful waterways provided power to run the nineteenth-century mills. *Wareham Free Library.*

other cotton mills were located in Wareham. One opened in 1816 by Curtis Tobey, Esq., and another in 1823 by Benjamin Lincoln. Both were located on the Weweantic River.

The power from the Weweantic River was also harnessed for a paper mill that Pardon Taber built in 1824. In 1864, a second paper mill was built by Wheelwright and Company near what was the Tremont depot.

HAVE A BLAST

With its easy access to timber, Wareham was a natural site to locate a blast furnace. In addition to having plenty of wood to fuel the furnace, there was also plenty of bog iron in the region. By 1804, a good portion of the ore used by the industry was shipped in from New Jersey.

The cargo landed in Wareham and then was brought to Carver and Middleborough, where the iron industry had been well established since the early 1700s. When the iron was transformed into products, the wares were returned to the port of Wareham for shipping.

In 1805, a hollow ware factory was established on the Weweantic River. A blast furnace takes iron ore and eliminates the waste material that accompanies it, turning it into molten iron. This hot liquid is then poured into molds to create bowls, trays, pots and other hollow ware.

A report on U.S. manufacturers from the 1880 census noted that in 1798, there were fourteen blast and six air furnaces, twenty forges and seven rolling and splitting mills in Plymouth and Bristol Counties. In 1804, there were ten blast furnaces in Plymouth County, all producing castings exclusively.

By about 1820, the manufacturing of hollow ware was the most thriving industry in the region, but the use of blast furnaces began to decline. According to the 1867 history:

> Whole forests of pitch pine timber were felled, and converted into coal to melt the moulton masses with which these various furnaces were continually charged. The introduction of hard coal and pig iron, completely revolutionized this business, and blast furnaces were abandoned.

Iron casting and iron manufacturing remained a profitable business, and the Franconia Works, located below the Narrows on the wharf, and the Agawam Works employed a number of workers.

WAREHAM NAILS IT

In the 1700s, nails were rare because iron was relatively scarce in the New World. This is why many older homes used post-and-beam construction and employed wooden pegs. In many cases, scraps of iron were heated and banged into crude nails. In 1777, Cumberland, Rhode Island's Jeremiah Wilkinson devised a method of cutting nails.

Ezekial Reed of Bridgewater, Massachusetts, invented a machine in 1786 that not only cut the nail but also put a head on it. Jacob Perkins of Newburyport, Massachusetts, improved this machine, and Ezekial's son Jesse Reed further refined the process to cut off the plate and head the nail in a single turn of the machine. By 1810, a machine was invented that could produce one hundred nails a minute, or six thousand an hour.

Between 1819 and 1822, Isaac and Jared Pratt from Middleborough took over the Parker Mills site on Elm Street and introduced the first machinery for making nails. At the time, Jesse Reed's machine was a relatively new invention.

Wareham soon became a center for iron and nail manufacturing. In 1822, Bartlett Murdock and Company built the Washington Iron Works on the Weweantic River in West Wareham. In 1827, Bartlett Murdock and George Howland opened a rolling mill and nail factory, the Weweantic Iron Company, also known as the Pole Works, and Tobey's Mill in South Wareham. In 1832, the Washington Iron Company was sold.

According to a 2009 feasibility study about the Tremont Nail Factory, in 1828, the iron company became the Wareham Iron Company and opened the Tihonet Works on the Wankinko River. This is noteworthy for several reasons. First, in order to create a pond and improve water power, a twenty-eight-foot-high dam was built. This created Tihonet Pond. Second, they dug a canal so boats could travel from the mill to Parker Mills Pond and built two locks so that boats could travel from Tihonet Works to Buzzards Bay. Finally, Wareham Iron Company is also credited with petitioning the state to annex the Tihonet section from Plymouth and Carver to Wareham so that both of their plants could be in Wareham.

The report points out that Noble Warren Everett's history described the Wareham Iron Works as being "one of the largest and best rolling-mills in the country, a puddling-machine for making iron, and 50 nail-machines." If this is true, then the Wareham mill predates the 1838 furnaces at Phoenix Ironworks in Pennsylvania, which is credited with being "the first specialized nail factory to produce its own wrought iron."

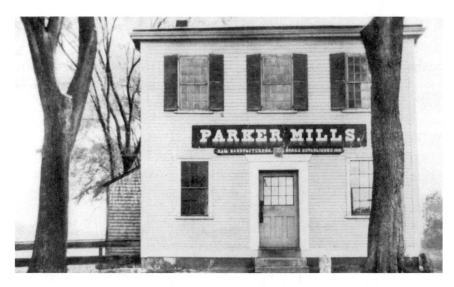

The Parker Mills was one of the major employers in town. *Wareham Free Library.*

The Wareham Iron Company failed in 1834, and a group of New Bedford men—John Avery Parker, William Rodman and Charles W. Morgan—took over the ironworks. Parker, who had owned stock in the Wareham company, operated the Tihonet site. When Bartlett Murdock and Sons' factory, the Weweantit Iron Company, burned in 1835, they rented the Elm Street site. In 1836, the factory in Wareham center also burned.

In 1845, Parker Mills took over the two sites. A corporation was formed by John A. Parker, Benjamin Rodman and Thomas J. Coggeshall, but soon, they added Samuel B. King as an investor and sold shares to a number of men, including Nahum Stetson. In the same year, Stetson arrived in Wareham to build works for the Tremont Iron Company in West Wareham and erect the high dam at Tremont Mill Pond.

Around the same time, the Parker Mill Company planned and built two factories in Wareham. The Tihonet plant was operating by 1845, but the Centre Nail Factory was probably not finished until 1848. Between the two projects, expenditures included bricks from Somerset Potters Works, a turbine wheel from Fall River and bills for plastering and boarding men who were probably construction workers. The Parker Mills office building was probably built around the same time.

Materials would have arrived by ship and then been transported over land by horse and wagons. Roadways were also improving, and by about 1832, a wood bridge replaced the rope ferry at the Narrows.

Two employees of the National Bank of Wareham, established in 1855. *Wareham Free Library.*

The whale, cod and mackerel fisheries peaked around this time, according to the Massachusetts Historical Society's reconnaissance survey. In 1844, 240 ships exchanged more than fifty thousand tons of goods. In the following year, 6 whale ships returned with more than $100,000 worth of whale and sperm oil.

To handle the influx of funds, the Wareham Bank opened in 1833, and a Savings Bank opened in 1847. The town's first railroad station was also built in 1847 and stood until 1892.

Access to Wareham changed even more dramatically in 1848 when the Cape Cod Branch Railroad opened and connected Middleborough to Buzzards Bay, passing through Wareham and including a bridge over the Narrows. Sandwich Street, which would become Route 6, was also improved from Wareham to East Wareham from the Narrows Bridge.

TREMONT HITS THE RAILS

One of the Boston men who organized the Tremont Iron Company was Nathan Carruth. He was president of the Old Colony Railroad Corporation, which was

A view to the east from the Tremont track. *Library of Congress.*

building a railroad between Boston and Plymouth. Carruth had the idea that Tremont could roll rails needed for the expanding railroads in the area.

Tremont Iron Company was one of the first companies in the region to make the T-pattern rails used by the Fall River Branch Railroad and others. Rails ultimately turned out to be unprofitable, so the company ordered nail machines and also made hoop iron. By the 1850s, it had twenty-three furnaces, three trains of rolls and ninety nail machines.

By 1850, Wareham Center was a totally different place than the area established by the town founders. The Cape Cod Railroad served the site by that year, and the Parker Mills was in operation. In addition, the railway provided a convenient vehicle to connect all the iron factories in Wareham with Boston and other key areas. Parker Mills was, by all reports, very successful. It bought pig iron and scrap iron and processed it into plates for the nail machines.

The *Tremont Nail Factory Feasibility Study* provided the following excerpt from the records of Parker Mills:

Nail plate was rolled at the Tihonet plant and floated down to the Centre Nail Factory, where it was cut into nails. The firm also rolled hoops initially, used to make kegs. The firm sold its products to hardware merchants through agencies in Boston and New York City. It could make nails to suit the preferences of customers in different markets. A merchant in New York City sent a sample of nails he asked the factory to make, "The F nails such as you make will not sell here." Nathan F.C. Pratt of Lazell, Perkins, & Co., who early on represented Parker Mills in Boston, sent samples but asked that the nails be made slightly smaller, "The slaters all complain of the size of these nails." Nails were made for various purposes, and the company also made spikes.

All was well until 1857, when the nation suffered an economic depression. Parker Mills nearly closed, but business picked up during the Civil War. After the war, faced with a depression in 1873, business slowed down again. In 1878, the mills shut down. Some workers remained, but the feasibility study notes that customers as far away as California were upset that they couldn't get their "favorite brand," Parker Mills nails.

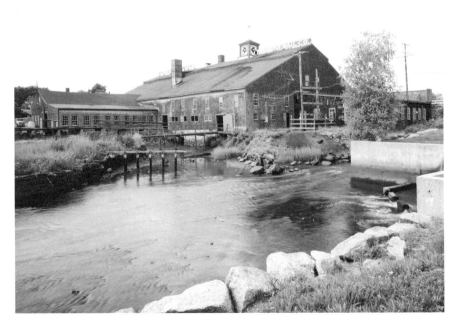

A view of the Tremont Nail factory from the creek to the main manufacturing building. *Library of Congress.*

Tremont Survives

Tremont Iron Company was sold in 1858 and became Tremont Nail Company in West Wareham on the Weweantic River. At about this time, the Tobey family became a key part of Tremont Nail Company when J.B. Tobey and later his sons took over the business.

When fire destroyed Tremont Nail, the company leased Tobey's Mill in South Wareham. It rebuilt and returned to Tremont village in 1867, when the South Wareham location became Wareham Nail Company. Another depression struck in 1873, and Tremont Nail closed from 1875 until 1877.

In the 1880s, wire nails became popular. They were produced by machine with steel wire. Cut-nail production declined, workers were laid off, wages were cut and some workers went on strike. In 1882, Bridgewater Iron Company purchased Parker Mills, and the new owners met with Tremont Nail Company and others to coordinate wage reductions. Workers in Bridgewater went on strike, and Parker Mills closed in 1886.

These nail-cutting machines were in use from the 1800s until the company moved to Mansfield in 2005. *Library of Congress.*

To keep up with the times, Tremont Nail added steel to its product in 1886 and then made what the feasibility study calls "a really bold step." The company opened a steel plant and made its own steel plate. In 1887, Tremont Nail Company bought the former Parker Mills site and took over the Elm Street site.

In the 1890s, Tremont Nail went into the fish-raising business and, in 1894, "received authorization to stock and take alewives, salmon, and shad from the Parker Mills and Tihonet ponds, and to construct fishways and outlets from the pond for this purpose." The company also added steam power in the 1890s, but still the company struggled to compete in the wire nail industry while cut-nail production continued to decrease in demand.

In the 1890s, the Standard Horseshoe Company was also operating in Wareham on the Weweantic River in the area where Murdock and Howland operated a nail factory in 1827 and Wareham Nail Company was located in 1872. The area retains its connection and is known as Horseshoe Mill.

In June 2012, the area became a conservation area operated by the Buzzards Bay Coalition and protected by the Massachusetts Department of Fish and Game. The coalition's website suggests it is a good place for bird watching and is home to frogs, turtles and other wildlife. But if you look closely, you can also find "slag." These dark, metallic pieces are a byproduct of iron ore processing. There are also building foundations and other remains from the area's industrial past.

By 1915, Tremont Nail was the only cut nail maker in New England, and the feasibility study reports that it was one of only fifteen left in the United States and Canada. James S. Kenyon Sr. bought the company in 1927, and his family operated it until 1989. The works in West Wareham closed, but the factory in Wareham Center operated using virtually the same process and equipment as it had since the 1800s.

When the Occupational Safety and Health Act was enacted in 1971, the 125-year-old factory asked for a variance because it could not meet the safety requirements. In 1975, the Massachusetts Historical Commission nominated the factory to the National Register of Historic Places.

In 1989, the W.H. Maze Company from Illinois bought the business. In 2004, the Town of Wareham acquired the property and leased it back to the company. By then, the company was making nails in the steel shed, and the old factory was vacated. In 2005, Maze sold Tremont Nail to Acorn Manufacturing Company of Mansfield, which closed the Wareham plant. In 2014, Acorn continues to make and sell the Tremont Nail brand. Though the last of the Wareham iron industry is gone from the town, its legacy lives on.

WAREHAM GROWS

The 1800s were a time of major change not only in terms of business and industry but also in terms of town life. Wareham grew from a small colonial settlement into a thriving center for business and then into a seaside destination.

After the Revolutionary War, Wareham and other small towns felt the economic impact. Although some profited from the war, Raymond Rider recalled, "Many poor farmers became poorer." In addition to the loss of lives and the need to care for the wounded, there were heavy tax levies imposed to pay for the war and its related costs. Sibyl Jerome's bicentennial history records the following details:

For the poor, there was little in terms of community support. They were sold to the lowest bidder at an auction at the town meeting. "The buyer was to victual and clothe the person bought and return his charge at the end of the year in as good condition as he found her (or him)," Jerome noted. In 1828, a poorhouse was built so that they could all be placed together; however, they continued to be sold to the lowest bidder. This continued until the poor were placed under the charge of the Overseers of the Poor.

Roads grew from the Wampanoag trails to the farmers' cattle paths to bridle paths. Soon, some roads became accepted by the town or were laid out by the county. Better roads were required for the carts used to haul farm produce and to deliver wood and iron to and from the mills that quickly grew in the early 1800s. Wooden bridges were located over the narrow part of the streams.

According to Jerome, the early roads were divided into highway districts, and improvements were paid by either a money or labor tax. "Sand, gravel, turf and mill ashes and cinders were mostly used in such improvements," he wrote. Later, oyster shells were rolled and crushed, and Wareham was noted for its excellent shell roads.

A Busy Place

Wareham was a bustling place beginning in the early 1820s. Jerome's history also provides the following description:

> *Tenement houses were built for the help, the schools were filled with pupils—there being over 800 pupils from five to 15 years of age in attendance in the middle of the century. The hum of machinery was heard, vessels plied at the wharves, scows were built to carry nails, iron ore, pig-iron, coal and other commodities to and from the vessels; locks were built to raise the scows from the river to the pond above. Puddling furnaces, rolls to roll hot iron, and nail machines to cut the nails were rapidly installed...Beautiful elms were set out to adorn the streets of the village. Many people moved into the town to seek employment. There seemed to be work for everybody and the town seemed prosperous.*

Although taverns and inns were already located in Wareham in the 1700s, the demand for them increased when Wareham became a stop on the route from New Bedford. The coach left Wareham each morning at 7:30 and returned at 5:00 that night. En route, it passed through Sippican and Mattapoisett.

The Fearing Tavern remains the town's best-known inn from that period, but there were also several others. The old Squirrel's Nest Inn, formerly Deacon Swift's Inn, was in East Wareham, and the Agawam Inn was run by the Galligans. There was another Fearing Inn on Main Street, which was then called Water Street.

When the Old Colony Railroad began operating in the 1840s, most of the inns closed. One that seemed to remain was the Old Colony Inn. It was located in a home built in 1825 by Dr. Benjamin Fearing. When his children sold the house, Margaret English ran it as a rooming house for ten years. It was a popular spot, and "Mother English" was known as a good hostess. Among the inn's notable guests is Calvin Coolidge.

NEW-BEDFORD & WAREHAM
ACCOMODATION STAGE.

A Stage leaves Wareham daily at 7 1-2

o'clock, passing through Sippican and Mattapoisett, and arrives in New-Bedford at 1-2 past 10. Returning, leaves New-Bedford daily, at 2 1-2 P. M., passing through the above towns, and arrives in Wareham at 5 o'clock.

Books kept at Wm. B. Taber's, at the Union Hotel, and at the Boston Stage Office, Union st., New-Bedford, and at Joshua Gibbs', Wareham.

All Baggage at the risk of the owner, unless receipted for by the driver.

ROBERT BURNS.

New-Bedford, Nov. 18, 1839.

The stagecoach was a popular way to travel in the 1800s and made stops at Wareham and other locations. *Wareham Free Library.*

Several inns and taverns provided for the visitors' needs. Among them was the Old Colony Inn, where Calvin Coolidge stayed. *Original sketch used with permission of Pamela Rainey Enos, 1988.*

In addition to the stagecoach, ships frequented the harbor. Jerome notes that it was not uncommon to see ten to twelve two- and three-mast ships waiting to discharge cargo and take on nails and iron goods.

From the late eighteenth century to the middle of the nineteenth, Wareham had a busy port. Many sailing vessels and whaling ships were built near what is now the Narrows, and a drawbridge was erected to allow the ships to pass. Among the vessels recalled by history is the whaling ship *George Washington*. Built in Wareham, it went on eight voyages of three years each and was captained by locals. They returned with sperm oil, whale oil and whalebone, which no doubt contributed to the local economy.

Another Wareham whaling vessel, the *Inga*, was captained by Elisha G. Cudworth and, in a little more than seven years, brought to port nearly five thousand barrels of sperm oil. The small but lucky brig of 160 tons was sold to New Bedford in 1848 and sailed for the Indian Ocean under the command of Captain Barnes. In 1852, its luck ended when the natives of Pleasant Island murdered the captain and most of the crew.

SALVATION IN A SHELL

From the time of the Wampanoags, one of the bounties of the local waters was oysters. Sibyl Jerome's history explains that the Wareham oyster, "planted on beds free from sewage and pollution, had a delicious flavor and was greatly sought for by city markets."

At first, Joshua A. Dill and Company from Boston had the contract to harvest oysters with the town, and the money received was distributed among the religious societies in town and sometimes to schools or for general town expenses.

After an act of the legislature gave Thomas Washburn the first oyster-harvesting license in 1854, the Wareham selectmen voted not to accept the act. In 1860, the town granted a shellfish license to Jonathan Bourne and then awarded many others. Harvesting these oysters became a very profitable business and a way to support the community.

It is not known which religious society benefited from the oyster contract, but beginning in 1830, a number of churches were founded in town. Before then, for almost one hundred years, the Congregational church was the only church in town.

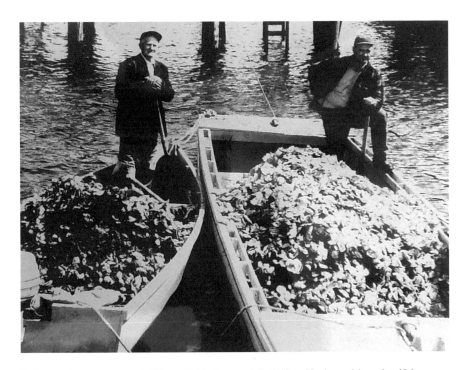

Father and son oystermen William E. Harlow and A. Clifton Harlow with a plentiful harvest. *Wareham Free Library.*

In 1830, a group of Baptists was known as the First Christian Society. The group had a pastor in 1831 who was active until 1837, when he moved to Rhode Island. Although the society had occasional preachers come in, it had no permanent pastor, and in 1865, it sold its church building to the Roman Catholics.

Also in 1830, a group of Catholics in Wareham worshipped as a mission church of the parish in Sandwich. Father Patrick Canavan was the first pastor. When the Catholics purchased the Baptist church in 1865, they renamed it in honor of St. Patrick.

In 1911, this group of Catholics became a parish and, in 1935, opened St. Anthony's chapel to serve the Tremont area of town. A new building was built in 1940, and the original Baptist church building now serves as a parish center. The parish remains active at the time of this writing.

St. Mary Star of the Sea Mission Church is a part of St. Margaret Catholic Church in Buzzards Bay. Although part of the Diocese of Fall River, the church has a history of pastors who have been Franciscan Friars, including the one who serves at the time of this writing.

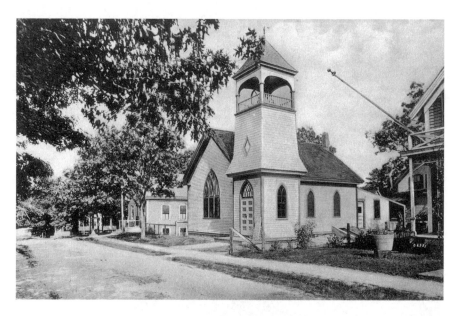

The Methodist and Spiritualist churches on Highland Avenue in Onset were featured on this circa 1910 postcard. *F.C. Small.*

Methodists have been part of the Wareham community since at least 1812, when Heman Perry and Covell Burgess from Sandwich held meetings in the house of William S. Fearing, Esq. Over the years, various preachers came to town, and by 1831, a Methodist Society was officially formed. Churches were located in Wareham Center, East Wareham, Onset and Oak Grove areas.

The congregations of the first three combined in the 1960s and are now the Wesley United Methodist Church, located on Main Street in Wareham Center. The church tower was destroyed in a hurricane in 1944, rebuilt in 1951 and weakened by Hurricanes Edna and Carol in 1954. It was unsafe and rebuilt after two years. In about 1993, it was again deemed structurally unsound. In 1996, the twenty-foot-high steeple was rebuilt and a bell from 1906 rehung.

To meet the needs of immigrants from England and Canada, an organizational meeting was held in Wareham in 1867, and the Church of the Saviour Episcopal Church was formed. The first service was held in 1868. Among the three baptized was Mrs. Susanna K. Tobey, who would become a major benefactor.

The first full-time clergyman, Major James Edmonston, arrived in 1882, and it was voted to purchase the Chapel of the Good Shepherd in West Springfield and have it dismantled and moved to the current High Street location.

The Congregational church and Everett School building in an undated postcard. The church burned in 1904. *H.A. Dickerman & Son.*

The building was erected on land donated by Mrs. Tobey, and the church was renamed the Church of the Good Shepherd. Originally, the church was wooden. In 1915, the stone tower was added, and the exterior was stuccoed. The Palmer Room was added in 1929 and then expanded in 1956. The parish hall was expanded in 1994, the bell tower was renovated in 2000 and a memorial garden was added the same year. The church continues to serve the community.

The Church in the Pines dates back to 1863, when it began meeting as the First Christian Church at the Tremont Schoolhouse. Parish legend says that when the church was being built, women collected rocks in wagons by day and men built the foundation at night by lantern light. The first service was in 1926, and for many years, the church was affiliated with the Advent Christian Church.

The church is now nondenominational and, due the many pine trees on the property, made its former nickname its official name in the 1990s. It continues to use local ponds for its baptisms.

The First Congregational Church remains active in a stately building that was built near the town center. It is the fifth church building on the same site. The gale of 1804 blew in one of the gable ends of the building constructed in the 1700s.

By the 1820s, the repairs needed were extensive, and the church was knocked down and replaced with a new church and a town house underneath.

Snow coats the First Congregational Church in this circa 1949 photo. The church is still in use in 2013. *Wareham Free Library.*

It rested on Quincy granite and boasted large windows and a portico, as well as columns in front and a bell in the steeple. It burned down in 1904.

A new, more modest Wareham Congregational Church was rebuilt, but it also burned and was replaced by the current stone building in 1914, which provides an impressive background to the town common. The Rowland Thacher Fellowship Hall adjacent to the church was named for the first minister.

In more recent years, several other churches have emerged to meet the needs of the faithful. Among these are the Emmanuel Assembly of God, the Emmanuel Church of the Nazarene, the Onset Foursquare Church, the Community of Christ, the Vineyard Crossroads Church, the New Life Christian Center and the Grace Lighthouse Fellowship.

Active Social Organizations

In addition to the churches, a number of social organizations started in Wareham in the 1800s, according to Noble Warren Everett's history. Among the earliest was the Social Harmony Lodge of Masons in 1823. The Masons met at Academy Hall and organized a lodge. In the lodge's

first year, twenty meetings were held, and large numbers of members signed up. By 1828, an anti-Mason sentiment was growing in New England and membership dropped.

In 1828, the members of the Middleborough and Wareham lodges combined and established a lodge in Wareham. No records exist between September 8, 1829, and 1956, when the lodge was reorganized, except for a December 2, 1829 special meeting, at which it was voted to move Social Harmony Lodge to Thomas Savery's hall in East Wareham. In 1856, the Agawam Lodge was established.

The Wankinquoah Lodge No. 119 of the Independent Order of Odd Fellows was organized in 1847 but gradually "weakened and died." It was reorganized on May 1, 1878. Also in 1878, the Wareham Lodge of the Knights of Honor was founded, and in 1881, the Everett Council of the American Legion of Honor was organized.

From 1848 to 1871, the Sons of Temperance were well represented in Wareham. At one time, the Wareham Division, the Agawam Division and the Sparkling Water Division all were organized. There was also a lodge of Good Templars that flourished for a number of years, as well as a Woman's Christian Temperance Union that was established in 1878. According to Everett's history:

> These organizations did grand work for the cause of temperance…Many confirmed drunkards were reformed and proved a blessing to their families, and were good citizens for the remainder of their lives. Financial help was freely given to families of the needy and many a "God bless you!" did the members of the Wareham Division No. 108 receive, as they tenderly cared for the sick and the dying. Deaths and removals finally caused the surrender of the charter, but the work performed will live forever.

At the end of the 1830s, the topic of slavery was beginning to grow throughout the country. The abolitionist movement was growing, and in the North, slavery was becoming scarce. In Wareham, legend has it that there were stops on the Underground Railroad. One was reported to be in the Fearing Tavern, but restorations and research seem to have proven that to be a myth.

Everett does recall an incident in 1838 at the Methodist Episcopal Church when Joseph Marsh was invited to deliver an antislavery lecture. The crowd became angry, and a rock was hurled at the speaker through a window behind the pulpit, but a heavy curtain stopped it. The speaker was taken to a place of safety.

At about the same time, the country was in a serious economic crisis. After the presidency of Andrew Jackson left the country with high inflation, unemployment and business failure, Martin Van Buren not only didn't take corrective action but also seemed to live well. The Whig Party chose William Henry Harrison to run against the president, and what happened next was what many consider to be the first real campaign for the office.

With the slogan "Tippecanoe and Tyler, too" and posters and badges that called him the "log cabin and hard cider" candidate, the country embraced the down-to-earth war hero. Campaign fever hit Wareham hard. One morning, about two hundred men felled trees and built a log cabin near the center of town. They erected a tall liberty pole and flew the campaign flag from it. Political rallies, called meetings, were held almost every night.

A smaller log cabin that could seat about twenty was mounted on wheels and used to bring groups to rallies in other towns. Everett reports there were poets, singers and well-known speakers, and the events were so popular that a gallery was even constructed to hold more people, mostly boys and young men, who cheered and stomped their feet.

School Bells Ring

According to the Wareham 250th anniversary publication, although there was a "School Mistress" as early as 1711 and later a schoolmaster, the early grammar schools only taught boys. Girls attended a dame school or were taught at home, if at all. The first teachers taught four months each in the east, the west and the center of town each year.

By 1845, there were eleven schools and a school committee. The town's first high school opened in 1867 in a building located just west of the town hall, which was rented from the Parker Mills Company. The sixty-five students were taught by one teacher. After the high school was destroyed by fire in 1889, land was donated on Marion Road, and a new high school opened in 1890.

THE WAR OF THE REBELLION

Although only one Wareham man fought in the war with Mexico, the War of the Rebellion, or Civil War, had a greater impact on Wareham. The War with Mexico began after the U.S. annexation of Texas in 1845. The war ended in 1848 with the Treaty of Guadalupe Hidalgo, which set the Rio Grande as the border and made Alta California and New Mexico territories of the United States.

Just a few years later, in 1861, the country was fighting the Civil War, and once again, Wareham responded by appropriating $1,000 for an emergency fund for families of those who volunteered to fight in the war. The town also raised a company of sixty-four men who were armed, equipped and uniformed at the town's expense.

Darius Miller, Albert S. Hathaway and Addison Alden were charged in that same year to form a coast guard of sixty-four men. Originally, the group was limited to men between forty-five and sixty, but the vote was amended to allow men over sixty years old to serve in the coast guard as well. Again, the town provided uniforms and equipment.

In the years between 1862 and 1864, recruiting continued, and the town also authorized additional funds to provide a bounty of $100 and $200 to volunteers who enlist. The women of Wareham also provided support by sending barrels, boxes and packages containing hospital supplies and underclothing to those fighting on the front.

Some family histories, including Dr. James Rufus Lincoln's, suggest that Wareham was a stop on the Underground Railroad. Lincoln, a descendant of the Revolutionary War veteran Rufus Lincoln, noted that a trail of secret passages brought slaves through the North to freedom in Canada. On Lincoln Hill, a loft in an outbuilding that included a carriage house was reported to be a hiding place in town. Some say one person who traveled the Underground Railroad through Wareham returned years later to express his gratitude.

In total, more than 320 Wareham men served in the army and navy during the war, and 39 died. According to the 1867 *History of Wareham*, they were:

Geo. H. French, B, 24th, [died] at Beaufort, N.C., Jan. 22nd, 1863.
Joseph W. Tinkham, 3rd Reg't.
Patrick Crim, K, 28th Reg't.
Thomas S. Hatch, C, 18th Reg't.
James F. Leonard, G, 18th Reg't.

Wm. Ashton, G, 18th Reg't.

Samuel Benson, G, 18th Reg't.

Theodore E. Paddock, G, 18th Reg't.

Arch. Stringer, G, 18th Reg't.

Patrick Cox, C, 58th, died Feb. 8th, 1865.

Jas. R. Russie, A, 20th, died in prison.

Stephen S. Russie, A, 24th Reg't.

Marcus Atwood, 18th Reg't.

Jas. Blackwell, A, 20th, died at Wareham.

Benj. F. Bumpus, A, 20th Reg't.

Daniel C. Bumpus, B, 24th Reg't, [died] Sept. 30th, 1864.

John J. Carrol, A, 20th Reg't.

Benj. D. Clifton, 20th Reg't.

John A. Haskins, 6th Battery, died at Washington, D.C., Dec. 6th, 1864.

Joseph Hayden, B, 24th Reg't.

John D. Manter, B, 3rd, [died] at Newbern, N.C.

James Maddigan, A, 20th, [died] at Wareham.

John R. Oldham, [died] at Deep Bottom, Va., Aug. 14th, 1864.

John S. Oldham, B, 3rd Reg't, died at Newbern, N.C.

Isaac S. Oldham, B, 24th, died at Beaufort, N.C., Feb. 2nd, 1863.

David A. Perry, B, 24th Reg't.

Daniel Westgate, 1st Battalion, Co. D.

Julian W. Swift, A, 20th, killed at Petersburg.

Horatio G. Harlow, C, 58th, [died] at Libby Prison.

Stephen H. Drew, 58th Reg't.

Geo. W. Besse, H, 58th, [died] July 2nd, 1864.

Geo. H. Loring, A, 20th, [died] at Libby Prison.

In addition to those above, other sources list the following deceased: Besse, Christopher C.; Bumpus, David C.; Connell (also spelled Cornel), James; Coyne, Patrick; Ellis, Harrison; Pratt, Andrew; Snell, Joseph. More than $32,000 had been spent by the town by the time the war ended on April 9, 1865. The Civil War remains the deadliest in American history.

A WARTIME WEDDING

By the mid-1800s, the nail industry was at its peak in Wareham, but so were the whaling, cod and mackerel fisheries, as noted in the Wareham Preservation Plan. The overall population increased with immigrants arriving from Ireland and other countries. Although modest cottages remained the norm for most people, those prospering from the industries in town built Greek Revival and Italianate homes in Wareham Center. Many well-known and wealthy people visited or had connections with Wareham. Among them was Tom Thumb.

In the midst of the Civil War, a wedding with a Wareham connection and worldwide appeal received great notoriety. In 1863, Charles Stratton, better known as Tom Thumb, and Mercy Lavinia "Vinnie" Bump were married. She was thirty-two inches tall, and he was thirty-six inches tall.

Vinnie Bump was a descendant of the Bumpus family who originally settled Wareham. As a child, she reportedly was encouraged to live a life hidden away from the public. Instead, she became a schoolteacher at sixteen, but she left town at seventeen years old to sing and dance on a Mississippi showboat owned by a cousin. Then, she met P.T. Barnum, who went on to manage her entertainment career. Barnum had also "discovered" Charles Stratton, at age five, and as "Tom Thumb," Stratton had become a superstar who spent his life in the entertainment business. Barnum introduced Bump and Stratton, and the two became engaged.

Theirs was considered to be the wedding of the century, and the Astors and Vanderbilts reportedly fought to be invited to the ceremony. They were married in Grace Episcopal Church in New York.

P.T. Barnum sold tickets to their reception, at which the couple greeted thousands of attendees from the top of a grand piano. In spite of the ongoing Civil War, Abraham and Mary Lincoln invited the Strattons to the White House for a reception in the Blue Room. Tiffany and Company gave them a silver coach.

In 1883, the couple narrowly survived a hotel fire in Milwaukee. Six months later, Tom Thumb died at the age of forty-five. Two years later, Vinnie Bump married an Italian dwarf, Count Primo Magri, and they operated a famous roadside stand in Middleborough, Massachusetts. Bump died in 1919 at about seventy-seven years old.

After the war, Wareham continued to be a center for manufacturing. The Wareham Preservation Plan pointed out that two new industries would transform the town: cranberry growing and summer tourism. In about 1860, one of the earliest bogs was built on White Island, and by

the turn of the century, there were thirty-seven cranberry growers in town. The area also again became known as a "summer home," this time for Victorians who headed to the waterfront to escape the heat of the cities inland.

SHORE SEEMS NICE

By the 1860s, the attraction of the waterfront of Wareham that drew the Wampanoags from their woodlands had begun to attract folks again. The trains and improved roads no doubt encouraged this exodus from inland, but so, too, did movements like Spiritualism. In Onset, the two were uniquely and forever connected thanks to the On-I-Set Wigwam.

During the nineteenth century, there were thousands—some estimate millions—of people who participated in Spiritualism, which David K. Naronis and others define as "talking with the dead." He suggested several factors that contributed to the growth of Spiritualism, including social and geographic mobility, encounters with immigrants, industrialization and revivalism—all inspired individualism and a freedom from traditional religious movements. It was very popular in the North.

Spiritualists rejected religious conventions. There were no sacraments or ceremonies. Spirits spoke through mediums, many of them uneducated women. Its beginning is traced to 1848, when Kate and Maggie Fox heard knocking and were able to commune with spirits.

The movement fit in well with the American Victorian fascination with death and mourning. After death, families and friends would reconnect in "Summerland," a heavenly community.

Like the Baptists and Methodists, the Spiritualists began holding outdoor meetings or summer camps. The Protestant summer camps mixed religious with leisure activities, while the Spiritualists seemed to include a much wider range of earthly pleasures. There were photography studios, billiard halls,

bowling alleys, shooting galleries, dance halls and roller skating rinks—and no lack of mediums. As Lilian Whiting wrote in *The Annals of Psychical Science*:

> *Psychics of every conceivable order take up their abode within the grounds: the "test" mediums, the healing, the materializing, the slate writing, the automatic writing; the trumpet medium; the medium who produces the independent voices; those who produce "spirit photographs" and portraits in colors; the flower mediums; the inspirational speakers; the palmists; the astrologists and astrophysics [sic]; the medium who has discovered the means of "conscious cooperation with nature," and can inform you (at the modest rate of a dollar a month, or ten dollars a year), how to avoid the mere stupid mistake of death.*

In 1877, Spiritualists formed the Onset Bay Camp Meeting Association, and in that same year, the Onset Bay Grove Association of Massachusetts was chartered by the state. It purchased a 125-acre section of Wareham on what was known as Pine Point and laid out seven hundred lots along with streets and parks.

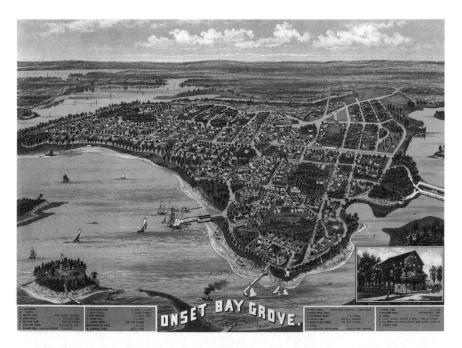

An 1885 perspective map shows a bird's-eye view of Onset Bay Grove that is not quite to scale. *Library of Congress.*

At first, it was a campground with tents dotting the wooded area that rolled toward the seas and rivers of Onset. Elvira S. Loring of Fitchburg built the first cottage, and others followed her lead, as did investors who built the businesses and halls that would support the leisure activities of the residents and visitors.

Houses were mostly modest Gothic Revival, Stick and Queen Anne cottages, with communal parks and beaches, as well as commercial development on Onset Avenue, according to the Wareham Preservation Plan. Soon, Onset became one of the largest Spiritualist summer camps in the country, complete with railroad access and trolley service for local transportation. People in Onset and the events there were covered by the *Boston Globe* and the Spiritualist publication *Banner of Light.* Among the spirits reported to appear at séances in Onset and at other camps were Benjamin Franklin and other famous Americans.

By 1891, Onset was a tourist destination. In addition to the Spiritualist campground, the Adventists established a camp meeting spot at Tremont. The Reorganized Church of Latter Day Saints held its first camp in Onset in 1911.

Folks headed to the shore for more than religious reasons. By the turn of the century, Victorians seeking to escape the summer heat headed to Onset.

A popular place to stay at the turn of the century was Onset Union Villa. *Wareham Free Library.*

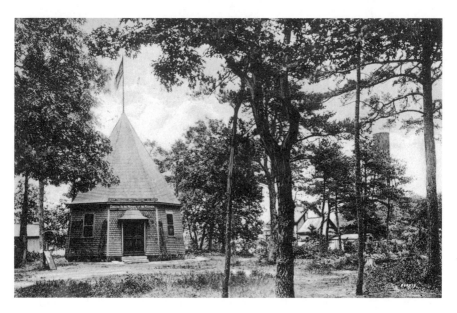

"Here's your favorite church" was the message on this 1908 postcard of the On-I-Set Wigwam. *Holmes postcard, Wareham Free Library.*

The *Boston Daily Globe* published "Peanuts, Spirits and a Good Time," an article that described the resort town where the paper estimated about two thousand cottages were located. The folks who lived or rented the small, and not so small, homes were joined on the weekends by two or three thousand more visitors.

Local law enforcement grew concerned about violations of laws, especially the infamous Massachusetts blue laws that prevented certain activities from occurring on Sundays. But others objected to the "vile creatures who, under the mask of mediumship, have been coining money from the most sacred feeling of the human heart," including the anonymous writer of an 1892 pamphlet with the provocative title *Some Account of the Vampires of Onset, Past and Present* who wrote those words.

He went on to describe the practices of some of the "vermin" who "with the cunning and all the artifices of the mountebank and prostitute, have plied their wiles to victimize and demoralize the heart-broken mourners seeking knowledge of their beloved dead." The pamphlet tells of Mrs. Hannah V. Ross and others whose spirits were actually children and others dressed in white and of cabinets with trapdoors, as well as magnetized paper and iron gates that shot up from the floor.

GIVING NATIVES A VOICE

Even among the Spiritualists, there was some concern about who was speaking and who was being ignored. Some felt that the powerful voices of the indigenous people were not being listened to by the mediums. As Russ H. Gilbert noted in *The Story of a Wigwam:*

> *A message from an Indian control, unlettered though it may be, is far preferable to one from an alleged Thomas Paine, Henry Ward Beecher, or some so-called ancient spirit; the language of which, in many instances, is inferior to that of the representatives of the "untutored" Red Man.*

From the start, some of the cottages were given Native American names, similar to practices at other camps, but in Onset, a group also built a "wig-wam." This structure, like others in Connecticut and elsewhere, was designed to remember the homes of the Wampanoags. Its use was reserved for Spiritualists who channeled deceased Native Americans, as William D. Moore explained in his article about a Spiritualist camp meeting:

> *In these wig-wams, a cultural group which was marginalized, disenfranchised, and massacred by mainstream America was given a voice by the Spiritualists. The mediums spoke as Native Americans who, they claimed, could no longer speak for themselves.*

The wigwam was built by a group of Spiritualists led by Mary Coburn Weston, who took over after the group's first president, Josephine Stone, died shortly after it was formed. Both of them, and the other organizers, wanted to bring the spirits of the native people to Onset Bay. According to the group's website, at the first meeting of the organization, organizers voted to call the society the On-I-Set Wigwam Co-Workers to honor an old chief from the area.

The wigwam was dedicated in 1894 with a healing pole in the center. Weston served as president and major benefactor from 1894 until she died in 1913. The fact that there was a female president speaks to the opportunities that Spiritualism gave to women.

Bernadine Rose Angelo, in her University of Massachusetts–Boston master's thesis, pointed out that Spiritualism gave women the same freedom as men but noted that men spoke in their own voices while women spoke under spirits' control. She goes on to discuss the décor of the wigwam, which

reflected a feminine perspective. This was no hunting lodge with animal heads mounted, as Angelo describes:

> *The interior of the Wigwam, which was photographed around the time of its opening in 1894 clearly shows a space furnished in the fashionable style of the 1890s. Fabric is draped artistically around nineteenth century prints of Pocahontas and William Penn and oil paintings of Native Americans done by Weston herself. In a strange nod to the trend of decorating with a Japanese influence which no fashionable home was without, the OWC added a plethora of paper fans that adorned the upper walls and continued to climb to the high ceiling…As in most homes of the time, area rugs were plentiful and other pieces of fabric were artistically draped on the wall, over furniture, and over some of the oil paintings, in a manner fashionable at the time.*

From the beginning, services at the wigwam were free. This was different from most of the other mediums operating in Onset, and perhaps the group didn't charge because it was aware of the frauds in town. What is also interesting is that the wigwam was built right near Crescent Park, a center of commercialized space on town. This not only provided a very public place for services but also gave the group access to the Onset Temple, a large hall facing the bay nearby.

The On-I-Set Wigwam Co-Workers also invited, or hired, Micmac tribe members to participate in festivals and functions, including the opening of the wigwam. Although the tribe was not local—it hailed from northern New England and Nova Scotia—members provided a Native American presence that blended the Spiritualism of the wigwam with the commercialism of the resort town. Among the most famous, and most photographed, was Mary Tony, who wove baskets that sold very well and were often ordered a year in advance.

A Natural Location

Unlike other planned communities of the period that used grids to organize the area, Onset Bay Grove used curved paths similar to the cemeteries of the time. These paths created areas overlooking water and surrounded by nature and were designed to encourage reflection.

Autos head to Point Independence from Onset Bay in this undated postcard. *Wareham Free Library.*

Moore explained that in the final decades of the nineteenth century, the camps brought together "railroad promoters, true believers, holiday travelers, professional mediums, and spectators in recreation activities." He noted:

> *While these camps where land met water and nature mingled with artifice, the Spiritualists inhabited a world neither enclosed nor exposed to the elements and brought into unity the worlds of the living and the dead, the sacred and the secular, the spiritual and the commercial, the male and the female, and the middle-class American and groups perceived as cultural other.*

Between 1883 and 1884, more than 150 summer cottages were built in Onset. The Point Independence Yacht Club was dedicated in 1909.

The town was planned so that visitors could easily navigate the community. Streets were designed to run east to west, avenues were to run north to south and boulevards were to circumvent the village.

For many, this escape by the sea was a place to come and relax. It's easy to see the attraction. Everett noted, "Many places on the coast-line of Massachusetts were visited...but although especial attractions were found...no place seemed to combine the advantages sought until [Onset] was found."

He continued to describe the wooded groves of oak and the two rivers that not only formed the boundaries but were also abundant in oysters and clams

for bakes and chowders. The roads were fairly dust free, and the spring water was good for drinking and cooking. There was fishing both in the ponds and in the ocean, and the Old Colony Railroad made the trip from Boston a two-hour ride.

Steamers and other vessels also brought passengers from Boston, New York and other locations. In his family history, *Prescription Filled*, Dr. James Rufus Lincoln recalled how he would travel from New York to Wareham during his childhood around the turn of the century:

> *The link between my New York and Wareham childhood was the Old Fall River Line. We left Lincoln Hill in a carriage and took the train at South Wareham. At Middleborough, the conductor would announce: "Change for Attleboro, Pawtucket, Providence, Fall River, Newport, and New York." This involved another train for Fall River and the boat. The sidewheel steamers of the Fall River Line include the* Puritan, *the* Pilgrim, *and the* Priscilla. *These were well-appointed and comfortable. A good night's sleep, a good dinner and breakfast, and such sights as the connecting rods moving rhythmically back and forth held the interest of the passengers.*

According to the Massachusetts Historical Society's reconnaissance survey, the coastal corridor provided access to Onset via a branch railroad service.

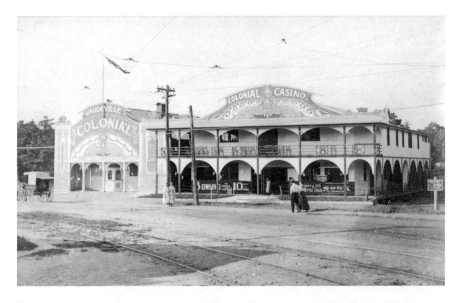

The casino was the "new dance hall" according to this 1910 postcard. *Wareham Free Library.*

Street railway lines from New Bedford extended along Marion Road and across the Weweantic River to Wareham and from Middleborough through West Wareham on a private way along the railroad tracks to Wareham. The lines continued over Main Street from the Wareham trolley route to Onset and via Onset Avenue to Point Independence.

To meet the needs of the many visitors and summer residents to Onset, restaurants and other venues, including the Colonial Theatre, opened. The theater featured vaudeville acts and silent movies as well as minstrel shows. The shows were so popular that the theater expanded and added the Colonial Casino. Its second-story dance hall hosted some of the most popular bands of the time. There was also a bowling alley and a snack bar.

The New Onset Theatre hosted the world premiere of the movie *7th Heaven*. According to Susan Pizzolato and Lynda Ames Byrne's *Images of America* book, the film featured Onset native Charles Farrell, who was hired by a vaudeville performer and introduced to show business.

Farrell also performed in minor roles with Lon Chaney, Mary Pickford, Charlie Chaplin and Douglas Fairbanks. He was dubbed the "Kid from Cape Cod" and played Vernon Albright in the 1950s television show *My Little Margie*.

NOT JUST FOR GUESTS

Onset not only catered to the visitors. It was, after all, a busy community in its own right. The Onset Water Company was established in 1894. It later became the Onset Fire District.

In 1923, the Onset Women's Club was founded. It established the first free saltwater swimming school in the country and outfitted it with lifesaving equipment like a boat and preservers. In addition to other civic projects, the group placed the fence around the Memorial Rock on the bluffs and purchased playground equipment for the town youngsters.

In addition to the attractions of the mainland, twelve-acre Onset Island is located just off the coast in Onset Bay. For the Wampanoags and early settlers, including the Fearings, it was a good place to gather oysters and other shellfish. Early history suggests that the female sachem who aided the English during King Philip's War, Ashwonks, gathered with her people there.

Three young pirates enjoyed Pinehurst Beach in a photo dated 1924. *Wareham Free Library.*

Three businessmen from Brockton bought the island in 1887 and divided it into 124 house lots. In 1907, there were eleven cottages and three boathouses. By the 1920s and '30s, the population of the island had grown, and there were many social events.

Although the hurricanes in 1938 and 1954 destroyed many homes, according to Onsetisland.com, about fifty people continue to have homes there as of 2014. The island is only accessible by boat.

There were lifeguards on duty at Onset Beach in 1928. *Wareham Free Library.*

Wickets Island is also located just off Onset. The town's 250th anniversary publication suggests that the five-acre site was named for Jabez Wicket, a Wampanaoag who lived there in the 1700s. Wicket was known to have fought in the French and Indian War, and the people of Wareham voted to pay him for the use of the island in 1739. After Wicket's death, another Wampanoag, Jesse Webquish, received a grant for the island. He died in 1810.

Several individuals leased the land over the next century, and a house was built there in the 1800s. It burned in 1947. Currently, the land is unoccupied, even though a developer in the early 2000s had the permits required to build a home there.

By 1890, the town was well established. According to the *Massachusetts Gazetteer*, there were twelve school buildings and two weekly newspapers, the *News* and the *Onset Bay Times*. In addition to the flourishing iron industry, there were fifty-five farms in Wareham.

About 40 residents worked in the fishing industry, primarily catching blue fish and harvesting oysters. To meet the demand, there were about sixty dories and sixty-one boats, in addition to five barks and three ships, engaged in commercial marine industries, and three schooners took part in ocean freighting. The town's 3,254 residents lived in 938 taxed dwelling houses according to the 1870 census.

ENSURING PUBLIC ACCESS

The Onset Protective League was organized in 1897 to keep public lands for the use of the public. At the time, there was a movement to use the bluffs and other waterfront land for homes. After a legal battle, the Massachusetts Supreme Court Decree of 1916 ruled that nothing could be built on Onset Bluffs, the parks or beaches. The exceptions were the bathhouses originally built by the Onset Grove Association and Profile Rock.

At the next town meeting, park commissioners were appointed. Over the years, they expanded their scope and became responsible for such things as improved street and beach lighting. The Onset Chamber of Commerce also was involved in a variety of civic projects.

The first and only Onset Library opened thanks to the Harvest Moon Society, which was formed by a group of women. They sewed and then sold their handiwork and held fairs, suppers, lawn parties and other events in order to raise money for a library.

They were able to buy a six-room cottage on Onset Avenue for $1,200 and opened a library and Women's Exchange, where they sold their works, in 1898. It was also used as a meeting place and became the Spinney Memorial Library, which is part of the town library system. It is named in memory of Mabel C. Spinney, who was active in the town.

BITTERSWEET CRANBERRIES

The iron industry required natural materials, and when the digging left indentations in the land, holes remained in which to plant cranberries. Other bogs were made by glacial deposits or hand-dug in the early days. Already growing freely throughout the area, cranberries began to be cultivated as early as 1816, when Captain Henry Hall of Dennis noticed that the wild cranberries in his bogs grew better when sand blew over them. He began transplanting the vines and spreading sand over them. Others noted his success and copied his method. It led to an increase in growers in the region.

The relatively mild climate of Wareham and the readily available water and sand made the town a prime choice for cranberry production. The Cape Cod Cranberry Growers Association explains that cranberries thrive in acidic peat soil, need adequate fresh water and sand and have a growing season that stretches from April to November. A dormancy period in the

winter is also necessary to mature the buds. By 1838, producers learned to use ice sanding and flooding to control insects and prevent frost damage.

At first, cranberries were picked by hand. Some reports of the early harvests describe them as joyous community events, but by most accounts, the work was time consuming, repetitive and often painful when the vines jabbed the skin. By the 1850s, cranberry scoops were being used, but it wasn't until later in the century, when they were refined, that scooping became the common way to harvest.

Most pickers were paid by the quantity harvested, as recorded in Robert S. Cox and Jacob Walker's *Massachusetts Cranberry Culture*. In 1830, Henry Hall paid his crews twenty-six cents per bushel. This increased to thirty-five cents by the 1850s and forty-eight cents by the 1890s. A good picker could make one or two dollars a day for the six-week season—not bad wages for an unskilled worker of the time. By comparison, a Union soldier earned thirteen cents per day.

In Wareham during the 1860s, cranberries were cultivated when a bog was constructed on White Island. In 1895, the Hayden Cranberry Separator Manufacturing Company was established, and R.C. Randall started a cranberry preserving factory in 1898. When Marcus Urann and others formed the United Cape Cranberry Company in 1907, there were thirty-seven growers in the Wareham Town Directory.

In order to record the production, superintendents, or overseers, were assigned to the field. Joseph D. Thomas's book, *Cranberry Harvest*, describes the process. Pickers were given either tickets or numbered pails to fill. When they were dumped, the overseer would record the tallies, and workers would be paid at the end of the season. Overseers also ensured that all of the berries were picked from the vines. If workers didn't pick the vine clean, the overseer would remind them "in a pleasant, but decided manner."

By the 1880s, growers began to look to the mills as a model to improve efficiency and production. As the owners adopted more and more of an industrial model, the workers became more organized as a labor force.

An 1895 *Boston Globe* story reported that owners were switching from pails to paper because "the pickers are up to all kinds of tricks." Workers would "accidentally" dent their pails so that the six-quart container might hold less than five. Owners compensated by demanding that workers overfill the pails. The days of happy harvests were over.

By the 1890s, owners had begun hiring cheaper—and they hoped more cooperative—immigrant labor. These workers came from all over. According to Cox and Walker:

"Kanakas" (Polynesians) from "the western islands" could be found in early years, having come to the region as a result of New England's ties to whaling and missionary work; and Finns, Russians and Swedes were thick on the ground, according to the Boston Globe *in 1892. There were French Canadians from Fall River, New Bedford, Providence and the cotton mills of Boston; and "Portuguese in whole families" came out, including both white Azoreans and black Cape Verdeans; along with diminishing "swarms of native Cape Codders," who came "from the 'tip end' of Yankeeland and intervening points along shore." New Jersey and Wisconsin would pad the list to include northern and southern Italians, Poles and African American emigrants, Oneida Indians, Puerto Ricans and even German prisoners of war during the Second World War. One wave of immigrants supplanted the next in a Moebius [sic] strip of mobility.*

The Bravas Arrive

In Wareham, "Bravas," or Cape Verdeans, would dominate the bogs for many years to come. Named for the island of Brava, the smallest but greenest of the ten volcanic islands that make up Cape Verde, the people who worked the bogs arrived on small schooners that made regular monthlong voyages to the island in the 1890s.

Because of their dark skin and African features, Cox and Walker suggested that they were looked on by many as "separate but unequal." Some Cape Codders suggested that the Bravas were "asserting" themselves by riding in the front of streetcars. Some area residents applauded their work ethic, but others made fun of their "primitive" ways and intellects. Many felt they had no ambitions but to be bog laborers, Cox and Walker wrote.

The U.S. Commission on Immigration reported on the seasonal patterns of the Cape Verdeans. It noted that every August, Bravas arrived from "the mills of New Bedford, from the docks in and about Providence and Fall River, from the oyster boats along the coast, from the ranks of the longshoreman, and here and there from out of the woods and wilds in the vicinity of the cranberry districts, and by twos and threes, by gangs, by hundreds, make their way to the fruit-laden bogs of Plymouth, Barnstable and Nantucket."

But whatever drew the hardworking Cape Verdeans to the bogs, many of them also made homes in Wareham and Onset's Oak Grove. In addition to working in the cranberry industry, they also labored on the railroads, and

Fanny Brito, who said she was nine years old, picking cranberries with her father on a bog in Wareham. *L.W. Hine, Library of Congress.*

many were employed by the Agawam Textile Company, or "the bleachery," in East Wareham.

As the community grew, the Oak Grove Elementary School opened to educate the neighborhood children. There was also an active 4-H Club and other organizations for the young and old. The Cape Verdeans had found a home and would become important members of the community in the twentieth century.

WAREHAM SEALS THE DEAL

I n 1900, Charles Lincoln Bates designed the first town seal. In addition
to the name of the town and the words *Nepinnae Kekit*, it featured a small
sailboat against a land background. Bates redesigned the Wareham seal in
1921 and replaced the sailboat with a Wampanoag in a canoe. It is still in
use as of 2014.

A new iron bridge replaced the wooden one over the Narrows in 1901,
and Sandwich Road became a more direct road. In her *GateHouse* interview,
Lynda Ames described Main Street, now Route 6, in the early 1900s.

E.N. Thompson's Emporium was the largest store outside New Bedford
and Brockton. It sold everything from ladies' hats to shotguns, she said.
There were also other establishments like Jessup's Jewelry; Bodfish and
Crockers Market; Cronwell's Furniture Store, which also housed Cronwell's
Funeral Parlor; and the National Bank.

The twentieth century also saw the establishment of town services. The
first town hall was built in 1901, and in 1903, Wareham established a police
department. Although Elwell Smith was appointed the first full-time chief of
police in 1917, it wasn't until 1929 that the town bought its first police car.

The Wareham Fire District was founded in 1907 to complement the
Onset crew. To provide services for areas not covered by either, there were
Forest Fire and Out of District Fire Departments in the 1900s. It wasn't until
2000 that the Onset and Wareham fire districts annexed the Out of District
Department. Although these departments now cover the entire town, they
are not under the oversight of the town but instead are separate entities.

By the 1900s, farming was on a decline in Wareham, with the exception of the cranberry industry. This 1907 postcard offers a humorous perspective to a visit to Onset. It's signed, "From papa." *Hugh C. Leighton Co.*

Entitled simply "The Road to Cape Cod," this undated postcard shows the early highway through town. *Wareham Free Library.*

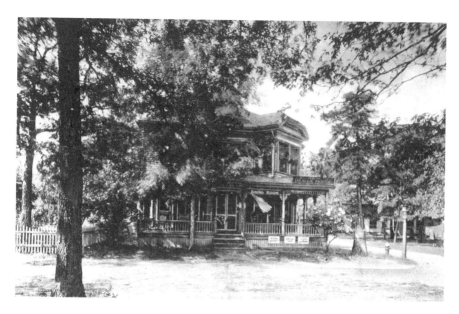

In 1910, the New Oracle House featured a dining room. *F.C. Small.*

The turn of the century also brought an increase in the number of schools in town. Large grammar schools were built. These included a wooden school in South Wareham; brick buildings in Oak Grove, East Wareham and West Wareham; and Pilgrim Memorial School in the center of town. Onset School, later known as the Hammond School, had stately columns and an assembly hall.

In his family history, Dr. James Rufus Lincoln recalls the amazing changes that the new century brought to town. The electric railway arrived in 1901, and by then, the steam locomotive, or "iron horse," linked the communities of the region. South Wareham in the early 1900s was a "whistle stop" or a "flag stop." The train would stop if a flag was put in place near the depot.

Lincoln also tells of the "Dude" train. It was made up of mostly parlor cars and ran between Hyannis and Boston, stopping at spots where the wealthy had homes. One stop was located at Indian Neck in Wareham, where there was a little depot called "Tempest Knob."

As access became easier, more visitors came to Wareham. In the early 1900s, new hotels, rooming houses and businesses attracted thousands of people to Onset. Some even called it "Hollywood East" because of the celebrities who would vacation there.

The Work Continues

Not far away, the community was also working, and many were employed by the growing cranberry industry. The Cranberry Growers Association history pointed out that in 1907, the New England Cranberry Sales Company became the first market cooperative, and in 1910, the Cranberry Experiment Station was established in Wareham. It was a research facility for the industry, and Dr. Henry J. Franklin was the first director. In the same year, a more efficient rocker scoop came into use, and in 1912, the first cranberry sauce was marketed.

Many of the cranberry bog workers were children. Between 1910 and 1914, noted photographer Lewin Hine took his cameras into the bogs and provided images of youngsters working in the fields. Robert S. Cox and Jacob Walker's *Massachusetts Cranberry Culture* cites newspapers of the time that reported the benefits of child labor:

> *Cranberry picking interferes somewhat for a short time with the schools in the village, but it is too much of a bonanza to be ignored; the children that go to the meadows are bright and wide-awake and at the close of the harvest sun are up in their studies with their classes.*

Most of the workers lived in bog houses, more commonly known as "shanties." The first floor was usually the kitchen, and the upper floors held bunk beds. Overcrowding was common.

In his self-published book *The Story Must Be Told: A Story of Cape Verdeans*, Querino Kenneth J. Semedo provides a look at the cranberry industry from a Cape Verdean perspective. The son of a cranberry picker who died while working a bog, his research indicated that not many people were aware of the contributions of the Cape Verdeans, especially in the early years.

From about 1910 to 1933, he explains, there were no bulldozers or heavy equipment, so the work was often done by Cape Verdeans who lived in mostly one-room buildings covered with tar paper. If the wood stove went out, Semedo's father said they would often wake with frost on their blankets.

The bog workers cut down trees, cleared stumps, wheeled sand, cut weeds, cleaned ditches and weeded the bogs in addition to picking cranberries. Semedo wrote that they worked eight hours a day, Monday through Friday, and worked their own small bog at night on Saturday. On Sunday, they would go to church and rest.

Joe Rose, eleven years old, dumps cranberries for his father. *L.W. Hine, Library of Congress.*

Semedo's father-in-law, John Lopes, also worked the bogs for more than forty-five years. He recalled checking for frost at two, three or four o'clock in the morning and having to turn on the water pumps to flood the bog and protect the cranberries. Today, thermostats control the sprinkler systems and turn them on and off.

At the end of the season, they would be paid and go to New Bedford to purchase food. Semedo noted:

> *The most important produce they stocked up with were 100-pound bags of rice, sugar, and beans. This was complemented by lard, corn meal and plenty of canned goods. This was to prepare for the long winter ahead. Before we returned home, my mother and father would go to a travel agency called Guilherme M. Luiz & Co., Inc., Bankers on Rivet Street in the South End of New Bedford, where they would make arrangements to send money to their family in the Cape Verde Islands. Mother had 4 sisters in Brava, Cape Verde. My father had a sister in Praia, Cape Verde.*

Boss of the bog, his wife and two children picking cranberries. L.W. Hine noted that nine out of seventy workers were between six and twelve years old. *L.W. Hine, Library of Congress.*

Semedo also describes the social and family life of the Cape Verdeans. Prior to the Depression, his father built a bungalow and, like many, maintained a vegetable garden to provide food for the family. They also had chickens and a goat. Socially, there were kitchen dances, a variation of Christmas caroling called *Canta Reis* and a celebration in nearby Rochester in honor of St. John.

In addition to the Cape Verdeans, the Finns also settled in Wareham. Many of them advanced to become foremen, and by the early 1900s, many had settled in Tihonet. Main Street in West Wareham was known as "Finntown," and a church and Finnish dance hall were established. By 1934, about seventy cranberry bog owners were Finnish, Joseph D. Thomas's book, *Cranberry Harvest*, estimated.

MAINTAINING THE PEACE

As with any growing community where residents, workers and visitors are brought together in close quarters, misunderstandings and even violence

could occur. As early as 1884, at the request of the Onset Bay Association, the first police officer, William A. Keyes, was appointed. Soon after, James W. Hurley was named the town's first chief of police.

In 1916, the Wareham selectmen organized the first police department under Chief Harry C. Snow. The following year, Elwell H. Smith became chief, and the town had twelve regular police officers in its first full-time force. Smith led the department until December 1928.

In addition to keeping the peace in town, Wareham residents also helped establish peace abroad. Although only two Wareham men fought in the Spanish-American War in 1898, more than two hundred were in the American forces in World War I. Among the town residents who fought was Donald W. Nicholson. He served in the U.S. Army overseas from 1917 to 1919.

When he returned, he served as a Wareham selectman, assessor and overseer of the poor. He served in the Massachusetts House of Representatives and then in the state senate, where he served as president in 1946 and 1947. From 1947 to 1959, Nicholson served in the U.S. Congress. He retired to his home in Wareham and died in 1968. In 1964, the Nicholson Bridge was named in his honor.

SHIPS AHOY!

The USS *Pomander*, a World War I U.S. Navy patrol vessel, has a Wareham connection. Although it was built as a private motorboat in Neponset, Massachusetts, on May 29, 1917, the navy chartered the boat from Bertram B. Conrad of Wareham for use as a section patrol boat during the war. It served until July 1918.

By the early 1900s, shipbuilding had returned to Wareham. Charles and Miron Gurney were successful wheelwrights when horses and buggies were common sights in Wareham and elsewhere, but in 1900, they decided to build a few rowboats. People liked them, so in 1903, they formed the Cape Cod Power Dory Company. Business grew, and they began building power and sailing boats.

In 1918, the Gurneys built two hundred lifeboats for the U.S. Coast Guard, and in 1919, they completed their largest ship: an eighty-footer of sixty tons that could carry passengers and freight. It was the first time in one hundred years that a big boat was launched in Wareham. The newspapers

The first large boat built in Wareham in one hundred years, the *Saltaire*, was constructed by the Cape Cod Shipbuilding Corporation and launched in 1919. The *Mercury* newspaper reported that the ship was eighty feet long. Schools closed, and a holiday was observed to celebrate its launching. *From a company report, Wareham Free Library.*

An early twentieth-century soldier at the station with a friend. *Wareham Free Library.*

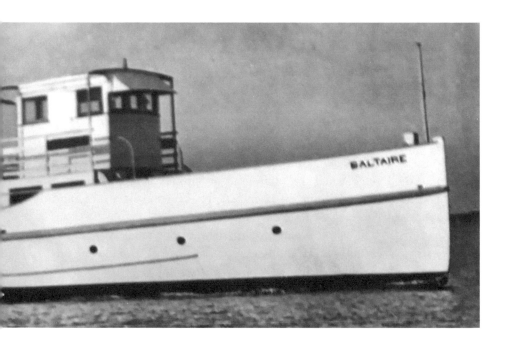

covered it, more than five hundred people viewed the launching and schools were closed for a holiday.

In the same year, the Cape Cod Shipbuilding Corporation was established, and a report published by the company notes that it built a new plant and yard and, in 1921, began producing boats, dories and yachts. Harvey Firestone purchased a number of twenty-two-footers with copper-sheathed bottoms and bronze rudders for Liberia, and others went to South America. Among the company's clients were admirals, governors and business leaders.

The end of World War I was celebrated in Wareham, but it was not without its sadness. Town residents Walter O. Bennett, Dudley L. Brown, Clyde Gariepy, Harry Gariepy, Everett F. Howard, Everett W. Leonard, Harry B. Jones and Paul L. Marville were killed in action, according to the town veterans' office.

The postwar era brought many soldiers home, but it was also a time of change.

Sweet Daddy Grace

In 1919, Bishop Charles M. Grace, better known as "Sweet Daddy Grace," opened his first House of Prayer in West Wareham, Massachusetts, where he owned a grocery store. In 1921, he began preaching in New Bedford.

Born Marcelino Manuel Graça on Brava, Cape Verde, around 1882, he was first seen in New Bedford in 1902. He spent time as a cook on a schooner that traveled back and forth between Massachusetts and Cape Verde and also worked the railroads in the South. The House of Prayer for All People, a black revivalist church, expanded to Charlotte, North Carolina, then to the Tidewater region of Virginia and finally to Washington, D.C.

He was believed to have performed miracles through the power of the Holy Spirit, and his followers numbered more than three million in cities throughout the United States. In addition to his church, he also developed a line of "Daddy Grace" products that included coffee, tea, soaps and hand creams, all reputed to have healing powers.

He died in 1960 at a time when his church was flourishing. In addition to his reputation as a healer, the church emphasized music and movement, including dance. A "shout band" was a key part of the church's services. This musical ensemble was marked by its use of sousaphone, baritone and trombone-based sound and was called "up tempo, bright and responsive to the congregation" in the notes from a 1996 documentary, *The Music District.*

Despite the church's popularity—or maybe because of it—the church was called a cult by some, and others objected to Daddy Grace's encouragement of congregations that included black and white members. In 2014, the church remains active with headquarters in Washington,

A 1952 postcard from Irene to Grandma and Anty O. features the Roman Catholic church in Onset. *Technor Bros.*

D.C., and more than one hundred locations, including one in New Bedford, Massachusetts.

A paper by Spinney Ottke, "The History of Onset," also recalls the beginnings of what would become the Portuguese Methodist Church on Onset Avenue, later renamed St. Mark's United Methodist Church. According to Ottke, the church began in town as a Sunday school started by Antonio Lombard of New Bedford at the home of Julianna Leite. The group outgrew Leite's home and so built a hall. Julius Bento of Cape Cod took over as lay preacher from Lombard, and the congregation increased. In 1925, Frederico R. Medina was ordained and served as the church's minister for fifty-two years.

Julius Bento's son, Spinney Ottke noted, was Judge James J. Bento. He served as Plymouth County Fourth District Court judge in Wareham and Middleborough. He remained active in the community and the church, where his wife served as organist.

Other Cape Verdeans joined St. Mary's Roman Catholic Church in Onset, and many served the United States both in the military and in other government service. Among those noted by Ottke was Eleanor (Penny) Faye Lopes Akahloren, who was in the U.S. State Department and was assigned to several embassies and councils in foreign countries.

INDUSTRY RISES AND FALLS

By the 1920s, the country began planning interstate highways. By then, what was to become Route 6 was already a well-traveled road. According to Dan Doucette of the Massachusetts U.S. Route 6 Tourist Association as reported in a *GateHouse* article by Gretchan Grundstrom:

> *Long before U.S. Route 6 received its official designation circa 1926 along with the genesis of the internal combustion engine and the heyday of rail travel, that route had already taken form as a community avenue to coastal activities as shallow draft sailing vessels reached far into our coastal system of bays, inlets, coves and rivers. Trade goods exchange depended on our coastal roadway and railway systems, including our earlier and more cumbersome modes of land travel and transport.*

Wareham's rivers fell an average of fifty feet in 1925. This allowed for the construction of dams. More than nine were built on the Agawam, Wankinco

and Weweantic Rivers. According to the Open Space plan, "grist mills, saw mills, tanneries, hollow ware manufacturers, cotton mills, paper mills, nail factories, and bog iron producers thrived. In 1928, a textile mill of modern design was erected on the Agawam River and operated for many years."

It didn't last long. The Great Depression struck, and by the late 1930s, only the Tremont Nail Company, Cape Cod Shipbuilding Company (formerly known as Cape Cod Shipbuilding Corporation) and Anderson's Boat Shop would remain as Wareham's major industries. Anderson's Boat Shop closed when the railroad bridge across the Narrows blocked the channel.

For the agricultural workers, the Depression hit especially hard. Commodity prices collapsed, foreclosures rose and employers slashed wages. Times were hard, but farm owners did receive some support from Franklin Delano Roosevelt's New Deal.

Workers felt that the support wasn't shared. As early as 1931, Ocean Spray Preserving Company workers laid down their scoops. Replacements were hired for the striking workers, and the action was contained to a limited area. In their book about cranberry culture, Cox and Walker suggest that things worsened in 1933 when not only were workers and owners in conflict

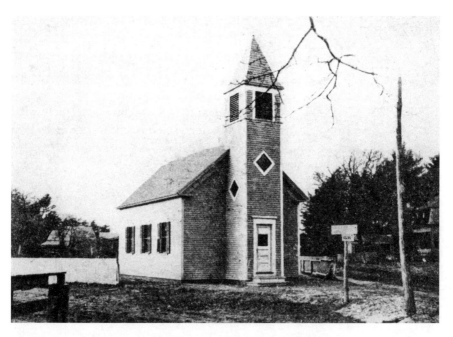

The Keyes Memorial Chapel in South Wareham served the Methodists until a new church opened downtown. It was moved to Gault Road and dedicated as St. Anthony's Chapel in 1935. *Postcard by D.D. Keyes.*

but town selectmen also got involved. Arrests were made, and charges and countercharges were exchanged.

In spite of the troubles, the 1930s were expansive years for the cranberry industry. Uramm introduced the cranberry juice cocktail, and Ocean Spray not only was formed as a grower-operated cooperative but also produced a syrup for mixed drinks and promoted dehydrated cranberries.

In 1930, the town also provided Onset with $500 for summer band concerts and $1,000 to repair the sea walls and a diving float. Merchants in that part of town sponsored a fund for Christmas lighting.

Despite the challenges of the economy, the 1930s were an exciting time for Onset. Locals tell of a nightclub on the road to Sias Point that hosted celebrities like Frank Sinatra, Bing Crosby, Benny Goodman and the Artie Shaw Band. Jimmy Cagney reportedly stopped by on his way to Martha's Vineyard, where his horse farm was located.

In 1933, an addition was added to the Wareham High School, which opened in 1908. It helped relieve the overcrowding, but it was clear that this was only a temporary solution. In the same year, the state police opened a barracks not far from the Weweantic River.

Lynda Ames noted in a *GateHouse* interview that across from the barracks, there was a bait shop with boat rentals operated by Charlie Savery. Near

In the 1930s, the Warr Theatre on Main Street and Water's drugstore were located near where the post office is today. *Wareham Free Library.*

Swift's Beach Road was A.R. Parker Ice Cream, and across the street were Barboza's Variety Store and Beaton's Market. Farther down the road were Smith's Market and Chevrolet dealership.

From 1933 to 1935, both the Sagamore and Bourne Bridges were built, which provide access across the Cape Cod Canal to countless motor vehicles. The canal had been expanded in 1931.

At about the same time, in the early 1930s, the town, inspired by the chamber of commerce, built two fieldstone lighthouses on opposite sides of Route 28. When their gates were opened, they symbolized that Wareham was the gateway to Cape Cod.

THE HURRICANE OF 1938

Nobody expected the hurricane of 1938. The storm came up suddenly from Cape Hatteras and headed up more than six hundred miles of coast in twelve hours, bringing with it more than one-hundred-mile-per-hour winds and turbulent, rising seas that wiped out entire areas of southern New England.

Wareham was hit hard. *New Bedford Standard-Times* reporter Everett S. Allen, in his book *A Wind to Shake the World*, describes the region after the 1938 hurricane. Ironically, it was his first day as a reporter and the story of a lifetime. But the scene was not a pretty picture.

Both the Narrows highway bridge and the railroad bridge were washed out. Water rose to a level twelve feet above normal on lower Main Street, and a floating gas stove from the Wareham Coffee Shop was used as a raft by two men trying to swim to safety. William S. Ross Jr., the manager of the Warr Theater, found a boat floating near the railroad tracks and rescued two men who were stranded standing on the counters of their businesses.

Although the railroad bridge over the Wareham River was washed away, Allen credits the railroad managers for noticing a boat floating over the rails. The engineer backed the train up to the Onset Station. In Onset, the property damage was devastating. More than 325 houses were washed away, leaving about four hundred people homeless. Boats were destroyed, and in all, more than $1 million in property damages was reported, Allen continued.

About ten acres of Swift's Beach was destroyed, and three people died. It could have been worse. The *Wareham Courier* publisher, Lemuel C. Hall, told tales of some heroes and a great deal of destruction.

Marguerite Bryant of Worcester was credited with saving her father, an invalid. She carried him out of the house and led other family members to safety. Then she went to the post office by boat, where she saved a mother and her two children and another woman. They were all on the roof of a building, which collapsed soon after they were rescued.

Wareham Police chief Chester A. Churchill was waist deep in water when he called his wife to tell her to leave town. He described the disaster:

> *We lost the people on the beaches because the water came in behind them and they couldn't get out. One husband and wife had planned to leave for Ohio the day before, but they postponed leaving because the weather was bad. They both were drowned.*

Onset Island was destroyed. Leroy P. Ellis tells of people being rescued from second-story windows and describes the island devastation:

> *Every house on Onset Island broke up and floated; there was eight feet of water over the island and one woman and son saved themselves by staying up a tree until the water went down…There must have been at least 20 big boats ashore after it was over…There was a man and some people drowned in a house in the canal when it smashed up against the Bourne Bridge.*

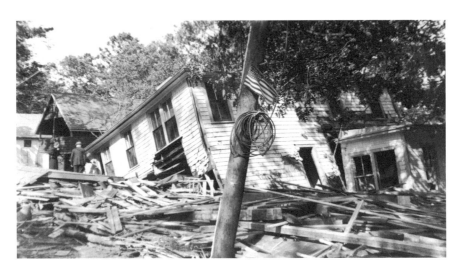

A scene from the 1938 hurricane found in a photo album, "Pinehurst Hurricane," dated 1925. *Wareham Free Library.*

A view of the dummy railroad station sometime between 1887 and 1900. *Wareham Free Library.*

The Dummy Bridge in Onset was also washed away in the hurricane. It was built to provide access for a small "dummy" locomotive engine, so named because the engine was either covered or modified so that the escaping steam noise would be muffled. The Onset train was big enough to bring about sixty passengers, along with baggage and some freight, from the mainland to Riverside. The train operated for a few years beginning in 1881, but then the bridge was widened and reinforced for vehicles and pedestrians.

When it was all over, the 1938 hurricane would be remembered as one of the worst disasters in American history with 600 people killed, 2,500 injured and more than seventy thousand buildings damaged. Wareham would never be the same after it.

CELEBRATION AND NEW CONSTRUCTION

The weather may have been calmer after the hurricane, but the cleanup continued, and Wareham began rebuilding and opening new structures. The 250th anniversary publication provided many of the following details.

After the 1938 hurricane and the death of William Minot, the owner, the Cape Cod Shipbuilding Company (formerly the Shipbuilding Corporation) reorganized and took on a slightly different name once again, the Cape Cod Shipbuilding Company. The new owner, Les Goodwin, was active in the community.

In his family history, Dr. Lincoln tells the story of how when some trees fell during the hurricane, he enlisted the help of his Boy Scout troop to not only help clean up the area but also learn woodcraft skills. The boys trimmed the trees, used handsaws and then moved logs to Minot's company, where he had a sawmill. The boys were able to see the trees go from trunks to boards and to learn about an important Wareham industry.

After nearly a year of construction, town hall was built on Marion Road in February 1939. This brick building still serves the town in 2014. In effect, along with the high school and other buildings, it created a new municipal center for the town.

The building was made possible by a Works Progress Administration grant of $95,000 and cost more than $200,000. It originally contained offices for all town officials, including those for police and veterans' groups.

In July 1939, the 200th anniversary of the incorporation of the town of Wareham was celebrated. The weeklong celebration coincided with the Fourth of July and featured a wide range of festivities. The perfect weather and decorated stores and public buildings set an ideal stage.

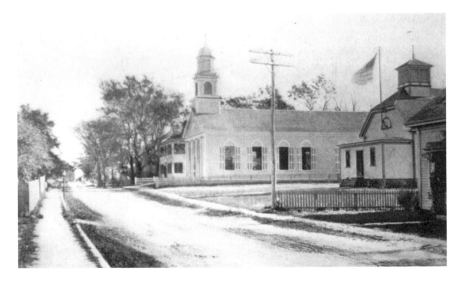

A view of St. Patrick's Roman Catholic Church with the school building next door, circa 1940s. *Wareham Free Library.*

The highlight was a bicentennial ball. More than seven hundred people participated in it, and many wore period costumes. There were both old-fashioned and modern dances, as well as a grand march.

In addition to celebrating the past, the town continued to build for the future. One year later, a new post office was dedicated. It opened on February 22, 1940, with a parade that started from Wareham Town Hall, proceeded down Marion Road to High Street and then continued on to Center and Main Streets. Dedication ceremonies were held at the new building.

More than 2,500 people visited the new Tobey Hospital on May 30, 1940. The hospital was established in 1939, and the new facility was the gift of the late Alice Tobey Jones.

A new St. Patrick's Church opened in 1940 to serve the growing Roman Catholic population in town. The large, white Colonial structure is located on High Street. The former church was moved to the back of the lot and serves as the parish center.

WAREHAM IN WORLD WAR II

When the nation went to war again, Wareham residents were willing to serve and to give their lives. The town's veterans' records report that among those killed in action were Joseph R. Baptista, James W. Barrows, Hugh Boynton, John W. Decas, Joseph B. Gomes Jr., Whilio A. Kassinen, Otto E. Kumpunen Jr., Horace F. Leaman, Frederick J. Murphy, Joseph Nunes, Charles W. Parker Jr., Harold F. Paulson, Chester Perry, Lawrence A. Pierce, Graydon G. Rogers, Alan W. Steadman, Reginald Vose and Joseph H. Whitehouse.

Seven other Wareham men died of wounds related to the war. They were Normand J. Charest, Armando N. Grassi, George M. Hunter, William M. Martin, Nahum H. Morse, Parker N. Moulton Jr. and Harry B. Queen. Hundreds more served honorably.

On the homefront, butter, cheese, milk, cigarettes, gasoline and other items were rationed. Especially along the coast, residents were required to shut off their lights at night so that the enemy could not get a good bearing on the U.S. shore.

Dr. Lincoln moved back to the family homestead in 1943. He recalls that having horses and wagons on the farm helped the family survive gas rationing. Gas consumption was strictly regulated by tickets given to people

In 1942, "Just Jackie" wrote, "This is the Main Street in Wareham—does it look anything like Hollywood Blvd? Perhaps, I should have said it is the only street in W." *Postcard by Technor Bros.*

who had shown that they needed them. As a doctor, Lincoln was able to demonstrate a need for gas.

He also tells about collecting scrap metal like pans and kitchenware. Recycling was a way of life; a pharmacist wouldn't sell a customer toothpaste unless he or she brought in an empty tube. Bacon grease and other animal fat was conserved and given to the government for glycerin.

The Civilian Patrol of Onset, like other such groups, would head out to the beach to watch for submarine activity. In a posting on Warehamwater.com, a person going by the username Danoconnell suggested that for his uncle and others who were in the Civilian Patrol, performing their civic duty was also a good opportunity to meet up with friends and have a few drinks while watching the water from the Onset Bluffs. The patrol members weren't the only ones who took advantage of the location. Many a young couple would head to the shore to "watch the submarine races."

But not all coastal activity was war-related or social. Out on Great Neck, the former Herrick House was transformed from a summer estate to a seminary for missionaries. The Order of the Sacred Heart assumed the property and opened the seminary in November 1943.

Another hurricane in 1944 hit southern Massachusetts once again. According to the *Boston Globe*, Wareham chief of police Churchill reported "very severe" damage at Swift's Beach and Swift's Neck. More than forty cottages were swept away. The railroad bridge in Wareham also washed away, and railway men worked by lantern light to make repairs. In Onset, a fishing boat smashed into a pier and part of the pier landed on the porch of a nearby taffy shop.

Meanwhile, the war continued, and many local residents sent their used books to the troops instead of donating them to local libraries. The Spinney Library in Onset closed and was used as a meeting place for Girl Scouts and other groups.

In 1945, the war ended, and products formerly rationed or scarce became more available. For Dr. Lincoln, that meant a call from George Cordes, who owned the Pontiac agency in town and knew the doctor needed a new car. He had a six-cylinder sedan for sale. The new car had a short wheelbase, which allowed the doctor to turn without shifting gears.

PARTIES AND TRAGEDIES

By the mid-'40s, Onset was once again a party town. There were restaurants and clubs offering nightlife and beaches to enjoy by day. Then tragedy struck.

One night in 1946, Ruth McGurk, a Cambridge woman on vacation, was abducted from an Onset dance hall and murdered. Nobody was ever convicted of the murder, and the negative press impacted the tourist industry.

Just one year later, Wareham was in the news for another tragedy. John Dos Passos, one of America's top writers, had just returned from England on the *Queen Mary*. A biography of the writer tells of a tragic Wareham connection.

After returning from visiting some friends on the lower Cape during the afternoon, Dos Passos was in a terrible accident. As he headed down the highway, he drove right into the rear end of a parked cranberry truck on Route 28 just off Elm Street near the town limits. His wife, Katy, died immediately, and Dos Passos's eye was hanging from his socket. They were taken to Tobey Hospital, where Katy was pronounced dead. The writer was taken to Massachusetts Eye and Ear Infirmary in Boston. Doctors were not able to save his eye.

He was interviewed by the police and said he did not fall asleep but was blinded by the setting sun. He didn't see the road, let alone the truck, and didn't have time to swerve or put on the brakes before the collision. Neither he nor the truck driver, who was slightly hurt, was held accountable.

A RETURN TO NORMALCY

As materials and manpower returned to the homefront, there was a gradual return to normalcy and, in some cases, new opportunities. Dr. Lincoln remembers new housing developments in East Wareham, West Wareham, along the Wareham River and on Hamilton, Cromesett and Swift's Beaches. But nowhere was the change as dramatic as downtown.

CHANGING TIMES

Although historically, downtown was the important commercial center during the town's early years when the ironworks and mills thrived, after World War II, the automobile would bring thousands to Onset and through Wareham.

Around 1949, Leo Corday wrote the jingle "See the USA in your Chevrolet," and Dinah Shore would sing it to her audience throughout most of the 1950s. For many folks, one of the places they wanted to see was Cape Cod, and that brought them right through Wareham.

As cars became more plentiful and family vacations affordable to many, there was enormous congestion through the center of town. And over time, Main Street changed drastically. Dr. James Rufus Lincoln noted:

> In the course of times Main Street was renovated. Newman's Dry Goods and Packard's Hardware, Waters Drug Store and Warr's Theater gave way to a Savings Bank addition and parking lot, and the drive-in branch of the National Bank. In the sixties, the time honored brick railroad station was razed due to discontinued passenger service.

He also recalls local landmarks such as Rider's Market, run by Raymond Rider, who was very active in civic affairs, including the Boy Scouts and the historical society. Lincoln's books remain excellent records of Wareham's history. Dennison's Shoe Store, Jim Nolan's drugstore, Jay's drugstore and the office of the *Wareham Courier* also were remembered fondly.

The Silver Moon Sea Grill on Buttermilk Bay in 1950. *Postcard by New Bedford News Company.*

Others arrived in Wareham by driving down Route 28, and many stopped at the Mill Pond Diner. It remains a '50s icon in 2014.

A diner has been located along Route 28, not far from the center of Wareham, since at least the 1930s. One of the earliest diners was Worcester Lunch Car No. 816. It started out as Aiken's Mill Pond Diner. Sometime in the 1950s, according to *Classic Diners of Massachusetts*, the Aiken family sold the diner to Ernest Blanchard.

Blanchard replaced the 1948 Worcester car with a slightly used Jerry O'Mahony diner that had been operating as Earnshaw's Diner in Fall River. The Worcester Diner later returned to Worcester, where the Turner family operated it as Charlie's Diner until 2002, when it was moved to Spencer but retained the name.

In about 1974, William Goyette is credited with bringing the Mill Pond Diner to its current location. He reupholstered the booths in blue in about 2009. The diner continues to serve customers in classic style in 2014.

By the 1950s, Ocean Spray began to market cranberry sauce in cans and also created an advertising campaign to encourage people to eat the sauce with chicken, not just turkey. What had become an often bitter battle between the two cranberry cooperatives in the nation—the American Cranberry Exchange and Ocean Spray—ended, but a pesticide scare in 1959 impacted

the industry. By the '60s, cranberries had bounced back, and in 1985, Ocean Spray became a Fortune 500 company.

The greatest increase in Wareham population growth, according to the Preservation Plan, took place after World War II. More than two-thirds of the town's housing was built after 1950. All the traffic heading to Cape Cod had to drive down Route 6, and the Cranberry Highway, as Routes 6 and 28 became known, became the major commercial area.

The '50s may have rocked, but destructive weather also rolled in.

DOUBLE TROUBLE IN 1954

Hurricane Carol hit the New England coast hard on August 31, 1954. When it was over, sixty-five people had died, and more than 4,000 homes, 3,000 boats and 3,500 cars had been destroyed. In Wareham alone, an estimated 1,000 cottages were smashed by the strong winds and pounding seas.

Boston Globe reporter Karl Banner shared the story of Nina Brown, the postmaster at Swifts Beach in Wareham. In the 1938 hurricane, she hung onto the roof of her Swift's Beach cottage for more than an hour while holding her seven-month-old daughter until she could jump from a piece of floating debris. She hopped from one piece to another until she reached safety on the dry shore, 150 yards away.

As the waters rose in front of the post office during Hurricane Carol, Mrs. Brown stayed to pick up two bags of mail. Mrs. Brown's now sixteen-year-old daughter waded across the waist-deep water to rescue four elderly people whose house was destroyed across the street. The second floor of the Brown house became a refuge for nine people during the storm. It was also the only one in the immediate area that survived the storm.

With Labor Day and the last hurrah of the tourist season slated to begin on September 6, workers hurried to get roads ready and the power and phones restored. In Wareham, the railroad bridge was repaired in time for the 8:45 a.m. train from South Station on the Saturday morning of Labor Day weekend, providing access to its shores for the long weekend.

Less than two weeks later, on September 11, Hurricane Edna struck, leaving blackouts, flooding and destruction in its path. About twenty people died during Edna's visit. Advanced warning was credited for the lower death toll than Carol's.

At 4:00 p.m. on September 10, evacuation of the already battered areas of Wareham was underway. The orderly retreat was led by Civil Defense officials and police, who drove through towns announcing messages through megaphones and police car loudspeakers.

About one hundred special police were ordered to Swift River Beach, Hamilton Beach, Pinehurst, Cromesett and Briarwood, the *Daily Boston Globe* reported. Nearly five hundred residents were relocated to the town hall evacuation center or to stay with friends inland.

The *Boston Globe* described Wareham as a "ghost town," with the wreckage from Hurricane Carol still visible on deserted shores, stores closed and people staying indoors. There was a major power failure, and some phone service was down.

In the calm after the storm, Wareham residents, business owners and renters rebuilt.

Coping with Cape Traffic

As Americans moved from cities to suburbs, private cars replaced public transportation. The trains stopped running, and the roads filled with cars. And during the summer it seemed like they all were on the roads that led to Cape Cod.

U.S. Route 6 and State Route 28 would become known as Cranberry Highway and would soon become the area's commercial center, surpassing the center of town. It also became a high traffic area.

After passing through downtown on Route 6, drivers usually faced an impressive traffic jam as vehicles merged from Routes 6, 28 and later 25 onto Cranberry Highway. The congestion during the summer also made it a very desirable place to do business, and between 1950 and 1970, the highway had reached capacity in terms of business.

There were strip malls and tourist shops, ice cream places and lots of fried seafood spots. Among the local spots was Lindsey's, which first opened in 1948 as a take-out fried clam restaurant. By 1968, it had expanded to a full-service restaurant. In 2014, it continues to serve its award-winning seafood bisque and other local favorites.

Kitschy local spots shared the road with McDonald's and other chain restaurants and stores. No doubt, some of these stores carried the popular "Chuck Taylor" sneakers made by Converse. In the 1950s and '60s, the

This postcard featured one of the town fire stations. *Postcard by Whale Deltiology published for Goodwin, Wareham.*

Converse Rubber Company and its basketball sneakers, made popular at Chuck Taylor's basketball clinics, were probably the most popular sneaker of the time. Few remember there was a local connection. Stephen Stone, whose family purchased the company in 1933, led the company in its heyday. He also sat on the Wareham School Committee.

There were also numerous trailer parks where mobile homes sat on small lots. These became somewhat of an issue because the owners paid modest property tax and the landowner just paid real estate tax. The funds collected didn't cover the town services provided, nor could they be counted as affordable housing to meet the requirements the state set in 1969. This presented a challenge to the town leaders.

In 1958, a new post office opened on Onset Avenue. Mrs. Mae McLaughlin was the postmaster. She was the third woman to serve in that position in Onset.

Hurricane Donna hit the coast in 1960, and the storm hit Cape Cod hard. Wareham sheltered three hundred people, most of whom were part of the 175 families evacuated from Swift's Hamilton, Briarwood, Pinehurst and Onset communities. Despite the damage, the town was not hit as hard as it had been in 1938 and 1954, the *Boston Globe* reported.

Preserving History

As the 1950s came to an end, the town looked to the future by accepting a gift from the past. In May 1959, the Old Fearing House, better known as the Fearing Inn, was donated to the town. The historic structure at Wareham Center was turned over to the Wareham Historical Society at a special meeting and culminated more than two years of work by the group to acquire the property.

"It's all yours," Ernest Blanchard reportedly said to the research committee of the society.

In 1963, the historical society also was given the old Roland Thatcher House, also known as the First Congregational Parsonage. In order to make room for the new Roland Thatcher Nursing Home, the structure was moved to land on Route 28 near Tihonet Road. The John J. Beaton Company of Wareham donated the land.

Route 6 Relocated

As early as 1947, the Massachusetts Department of Public Works announced plans for a "Relocated U.S. 6" project to handle traffic from Providence to Cape Cod. In 1953, an Interstate Study Committee brought together officials from Massachusetts, Rhode Island, Connecticut and New York to announce plans for a 260-mile-long "Cape Cod Expressway."

Federal funding for an extension of I-95E was approved in 1956, and construction began in 1958. But the designation of the section from the Massachusetts–Rhode Island border to New Bedford was changed to I-195, with the remainder of the road to the Cape still known as "Relocated U.S. 6."

Work progressed on the highway, and the first section between Providence and Seekonk opened in 1960. As the highway moved through Fall River, forever cutting a canyon through the heart of the city, a master plan was presented in 1963 at the Wareham Town Meeting that included an interchange at the terminus of the highway on Main Street near Lincoln Hill.

Needless to say, Dr. James Rufus Lincoln and others were not amused. Lincoln stressed that the historical significance of Lincoln Hill cannot be disputed. It was here that Captain Rufus Lincoln, the author of one of the most important firsthand accounts of the Revolutionary War, lived and where his family, who protected and published it, continued to live.

Dr. Lincoln produced a brief brochure to outline the historical importance of the farmhouse, its owners and the family heritage. Apparently it worked, or at least helped. The location of the new highway was moved from Main Street to Route 28.

But that doesn't mean the Lincoln landscape remained unchanged. About seventy acres of family-owned woodlands were taken by eminent domain. Bulldozers moved in and cleared the land. Ancient trees were burned in huge bonfires.

But not all was lost. Conant Hill, located adjacent to what is now I-195, was the site of a Wampanoag encampment. Relics found by Dr. Maurice Robbins, a noted archaeologist, were brought to a museum in Attleboro. About twenty-three acres left after the road was built was donated to the Plymouth County Wildlands Trust.

A gift of Dr. James Rufus and Helen P. Lincoln in 1976, the 23.4-acre Conant Hill Preserve is described by the Wildlands Trusts as a parcel that has changed from an open field to a "fine, open woodland" that includes white pine and red cedar trees, as well as several species of fern. The trust notes:

> *Tucked into a curve of the meandering Weweantic River, Conant Hill rises 40 feet above the riverbed. A wealth of historic associations and natural features make this an intriguing place. The marsh and riverbed are a birder's delight, while anglers find attractive spots on the banks of the Weweantic River to fish for smelt and white perch.*
>
> *It overlooks both the remains of the historic Standard Horseshoe Works and Interstate 195, which runs through what was a larger piece of property acquired in 1957.*

TIMES ARE CHANGING

Across the nation, the 1960s and '70s brought change and challenges. Hundreds of Wareham men served honorably in the Vietnam War, and three did not return home. Richard H. Arruda, Ronald L. Bumpus and Carlos J. Rose were killed in action, according to the town's veterans' site.

From 1936 until 1964, Route 6 was the longest highway in the United States. It connected Bishop, California, to Provincetown, Massachusetts, and it still passes through the heart of Wareham. Also known as the Grand Army

of the Republic (GAR) Highway, it became the second-longest highway when California renumbered its highway system.

During the 1960s, construction continued on an improved highway to connect Providence with Cape Cod. Interstate 195 brought the highway to New Bedford in 1966. What was originally the Route 6 relocation became a four-lane continuation of the I-195 highway that ended in Wareham with what is known as a "trumpet interchange," a straight road that ends in a loop that connects to MA 25 and I-495. After many years of delay, it opened in 1987.

Route 495 is a major beltway in Massachusetts. It connects Salisbury, Massachusetts, at the New Hampshire border with Wareham. As it loops around Boston, it connects with interstate highways 93, 95, 290 and 90 (the Massachusetts Turnpike), as well as Routes 2, 3 and 25.

Although Cape Cod baseball began in 1885, the Wareham Gatemen have been playing ball only since 1969. In that time, almost 900 collegiate baseball players have worn the uniform, and as of 2010, according to the team website, 236 major-league players can trace their beginnings to the Gatemen.

Among the Wareham players who have moved on to the big leagues are Mo Vaughn, Barry Zito, Carlos Pena, Chuck Knobloch, Ben Sheets, Lance Berkman, Aaron Hill, Justin Masterson, Jeremy Sowers, Ike Davis and Daniel Bard.

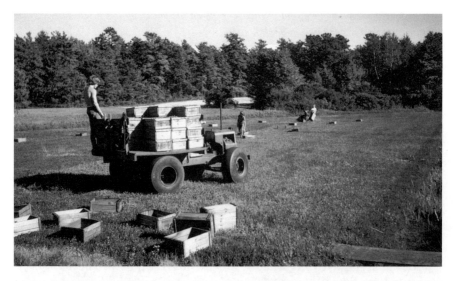

Some things don't change. (Foreground to background) Billy Ames, Jens Jensen and Virginia Dickess worked the Ames bogs in the 1970s. *Wareham Free Library.*

In the 1970s, Wareham built two affordable housing developments under the "Section 236 program," which provided interest rate subsidies in exchange for subsidized rental units. Brandy Hill in East Wareham includes 132 units on State Street and was purchased in 2010 by a Boston nonprofit, Preservation of Affordable Housing Inc. Agawam Park on Sandwich Road provides housing for the elderly and handicapped. It is operated by the Wareham Housing Authority, which also oversees Redwood Park on Church Avenue.

The 1970s also brought a renewed appreciation for the town's history and the importance of preserving it. In 1971, two historic districts were created: Center Park Historic District, which protects the area around the old town hall, and the Parker Mills Historic District, which covers the area around the Tremont Nail Factory. The Wareham Historic District Commission reviews applications for alteration and new construction in these areas.

A small earthquake centered about five miles north of Wareham rattled windows and tumbled dishes off shelves on December 20, 1977, the *Boston Globe* reported. "We must have got 30 calls in one minute," a Wareham police officer said. "They all came in at once. We received no reports of damage."

The 1980s brought more changes to the town, some bad, some good and some famous.

At the 1980 annual town meeting, four scenic roads were protected under a "Scenic Road Bylaw" adopted by Article 48 at the meeting. Any changes to Stillman Drive, Great Neck Road, Stockton Shortcut or Indian Neck Road from Minot Avenue to Indian Neck, such as removing trees or stone walls, now require a public hearing.

A fire at the Ebb Tide in 1982 destroyed the Onset landmark. In 1985, a fire also damaged the Tobey Homestead. It caused extensive damage in both the L wing and the main building. About one hundred firefighters from Wareham, Sandwich, Carver, Rochester, Marion, Onset and Bourne worked for more than three hours to control the blaze.

In 1986, the Narrows Historic District was created to protect parts of the waterfront in Wareham. Like the Center Park and Parker Mills Historic Districts, changes in the area are reviewed by the Wareham Historic District Commission.

With the opening of Route 25 in 1987, traffic on Cranberry Highway was reduced by more than half. For travelers, this was good news, as they now could drive straight onto the Bourne Bridge. But by doing so, they bypassed the businesses that depended on the flow—and sometimes lack of movement—on Route 6. The *Boston Globe* noted that the new link from

Downtown in 1984 was still a busy place during the summer. *Wareham Free Library.*

Bourne Bridge to Interstates 195 and 495 would bypass "the Route 28 honky-tonk strip in Wareham" and would "spare weekend drivers huge delays down the highway dotted with stoplights, fast-food restaurants and souvenir stores." Without the traffic, however, many small businesses closed their doors.

The seven-mile, six-lane, $35 million project came after a twenty-year battle, the *Boston Globe* continued. A key part of the dispute involved the need to prevent road salt from contaminating the cranberry farmers' crops. In July 1986, state environmental officials imposed twenty-one safeguards on the Department of Public Works, which cleared the way for the new highway that now provides a straight path from the interstates to and from the Bourne Bridge.

Across town, Onset was experiencing a renewal of sorts. This time, it wasn't from a religious event but a real estate transformation.

In 1987, a small, town-owned golf course was purchased by Bay Pointe Village and Country Club, a group of business professionals that came to town and saw its potential. Some credit their $1 million purchase with helping revitalize the town. Plans were soon put in place to build up the golf course, put in a country club and build twenty-five condominiums to be called Bay Pointe Village.

At about the same time, Len Cubellis bought and refurbished the Onset Pointe Inn, and since then, he has purchased and refurbished an additional

twenty-three buildings. Len was also instrumental in creating the Onset Bay Association (OBA). The association has worked to promote the tourism growth in Onset. In December 1995, the association was approved for a state-funded grant of $400,000 to improve Onset's downtown. This money was funded through the state's Executive Office of Communities' Development; it affirmed a year-and-a-half-long project headed by the OBA director.

These funds were used for improvements to storefront signage, refurbishing the Onset band shell and making it handicapped accessible. These improvements have helped make Onset a thriving summer tourist place. The storefronts all have colorful new faces, and they enhance the town's Victorian charm.

The Onset Bay Association is also responsible for hosting events. It hosts events such as the Onset Bay in Bloom: A Victorian Tea, the Summer Concert Series, the Blues Festival and Illumination Night, an annual lighting of the beach. A huge Cape Verdean celebration also draws people to town.

WAREHAM ON THE BIG SCREEN

In spite of the ebbs and flows of the traffic, one business made a splash and continues to stay afloat. Water Wizz opened in 1982 and not only survived but also achieved star status by being featured in two major films. The 2010 Adam Sandler flick *Grown Ups* filmed there but didn't mention the park by name, although signs with the name are visible in several shots.

In 2013, *The Way Way Back* featured Water Wizz Water Park by name. Trent (Steve Carell) and Pam (Toni Collette) play a dating, divorced couple who bring their families to a summer house on Cape Cod. Pam's son Duncan (Liam James) makes friends with the manager of Water Wizz. Although mostly filmed in Marshfield, Onset and the Cranberry Highway play supporting roles.

A *Boston Globe* article in 2013 noted that the family-run, eight-acre water park still draws about 100,000 visitors annually. Attractions include water slides, a wave pool, tubes to float along a running river and kiddie attractions.

In 1988, Wareham native Virginia Elizabeth "Geena" Davis won an Academy Award for Best Supporting Actress for *The Accidental Tourist*. She has also appeared in *The Fly*, *Beetlejuice*, *Thelma & Louise*, *A League of Their Own*, *The Long Kiss Goodnight* and *Stuart Little*.

Her first film appearance was in *Tootsie*, and she performed in a number of television shows, including *Buffalo Bill*, *Family Ties*, *Remington Steele* and her own sitcom, *The Geena Davis Show*. In 2005, she won the Golden Globe Award for Best Actress in a TV series for her role in *Commander in Chief*.

Davis has been active in fighting gender discrimination both in sports and on television, where male characters outnumber female by nearly three-to-one. She was not athletic growing up, but she took up archery in 1999 and was an Olympics team semifinalist.

She attended Wareham High School and served as an organist at the Congregational Church in town while still a teenager. She also has a special named after her at the Mill Pond Diner.

A 250TH Anniversary

The 250th anniversary of the incorporation of Wareham was held in July 1989. Again, the celebration coincided with the Fourth of July holiday, as well as with Cape Verdean Independence Day, which was marked during the same week.

The town anniversary began with the ringing of church bells and an opening ceremony on Onset Bluffs. Again, there were church services, square dances and a grand Anniversary Ball, but there were also a Wareham Gatemen baseball game and a reception for Anna Marie Cabral, the widow of a national hero of Cape Verde.

On Saturday, there was a reenactment of the British invasion of Wareham; a huge birthday party at Wareham High School, featuring a "Taste of Wareham"; and a grand reunion of all high school classes. The largest parade in Wareham's history took place on Sunday, and the actual anniversary day, July 10, was marked with a concert and ceremony, including an address by the mayor of Wareham, England.

In addition to the celebrations, there was a permanent tribute erected to the native peoples of the area as part of the 250th anniversary. *Aquene* is a young Native American woman sculpted in bronze by Clayton Fuller, who returned to sculpting and printmaking in 1962 at sixty-seven years old. Dressed as she would have been during the summer about 1,500 years ago or so, the statue sits on the Onset Bluffs, a historic spot overlooking the water. At first, the statue was controversial because of its bare breasts, and there were attempts to clothe *Aquene*, including a metal bra that the artist kept as part of his collection of *Aquene* artifacts.

Some local Wampanoags, including Hazel Oakley, a sixty-four-year-old elder of the tribe, also felt it symbolized exploitation of native women. The controversy received national coverage in the *New York Times* and the *Daytona Beach Sunday News-Journal*, among others. In 2014, *Aquene* remains ageless—and topless—twenty-five years later.

The 1990s were interesting times in town. There were allegations of illegal strip searches, missing library books and funds and battles over affordable housing. In addition, there were struggles balancing the town budget, in part because of a major cut in local aid from the state. Between 1982 and 1992, the Massachusetts Budget and Policy Center estimated that the general local aid, adjusted for economic growth, dropped by nearly half, from about $5 million to $2.4 million.

There were some positive changes. A new Wareham High School building opened in 1990, providing a modern home to the town's students. In addition, the East Wareham, Ethel E. Hammond, John W. Decas and Minot Forest Elementary Schools were all renovated between 1989 and 1997.

WIGWAM REDEDICATED

The Spiritualist wigwam in Onset was rededicated and the pole resensitized on July 30, 1994, as part of the On-I-Set Wigwam Co-Workers' centennial celebration. The On-I-Set Wigwam and Spiritualist Church continue to have Sunday and other healing services and mediums' days, as well as galleries, workshops and fire circles. In 2014, the group claims to be the oldest National Spiritualist camp to have religious services in a wigwam.

There is also a small structure that houses the First Spiritual Church of Onset. It sits quietly on Highland Avenue, which is just off Onset Avenue, a curving road that runs through town. Today's Spiritualism defines itself as a science, philosophy and religion. Members believe that man is a spiritual being and that there is no death. It is a change of condition. Spiritual healers are believed to be able to pass healing forces on to the patient but do not deny the need for physicians and surgeons.

The wigwam and the Spiritualist church both continue to be located in the middle of a residential area not far from the water. The roads around them are natural and bring the traveler along the rhythms of the land. That was part of the community's design and part of the area's continued appeal.

NEW BEGINNINGS

As the twentieth century ended and the new century began, Wareham took a look back as a way to preserve its future. Public Archaeology Lab prepared the *Wareham Reconnaissance Report* for the Massachusetts Department of Conservation and Recreation. It provides an overview of planning issues, including how development is threatening the open space and natural environment, but it also highlights the rich historical resources of the town.

Among the areas identified as having great significance were the Agawam River, the Wankinquoah River and the Weweantic River watersheds. An ancient Wampanoag route through the Weweantic watershed was also listed as a "not well documented" but significant cultural resource.

Horseshoe Pond, Tremont Dam and Wicket's Island also made the list, as did Greer Lumber, the Captain John Kendrick House, the On-I-Set Wigwam, Fearing Tavern, the Tobey Homestead and Cranberry Commons, the former Ocean Spray headquarters.

The report recommended intensive study for the Wankinquoah watershed, Horseshoe Pond, Tremont Dam and Cranberry Commons. The neighborhood around the oval green at Crescent Place in Onset was also singled out as a potential National Register of Historic Places nominee.

WAREHAM'S GHOSTS

The town continues to be a place where the past and present come together. And some suggest the line between then and now sometimes is blurred.

As host of a paranormal radio show since 2005, Wareham resident Tim Weisberg has been able to investigate some local legends, and his 2010 book, *Ghosts of the SouthCoast*, provides an interesting perspective. He reports that he found what might be a tunnel under the Fearing Tavern and claims that a recording device picked up a voice saying that it had killed "Grandpa."

Other strange phenomena reported were a glowing orb among old toys, other conversations and an iron gate being slammed. Close by, voices of British soldiers and muskets are reported near the Tremont Nail Factory, not far from where the *Nimrod* attacked the town.

In East Wareham, Weisberg says that Wampanoag spirits and the ghosts of cranberry workers make their appearances near Glen Charlie Road. This is near the location of the Agawam Nail Works and an area that was reported to be a favorite spot of Daniel Webster, the American statesman.

A *Boston Daily Globe* report in 1885 focused on how the Glen Charlie area was a favorite of Webster, but it also made an unusual observation:

> *Whenever a tempestuous storm is raging in this locality, a most singular specter exhibits itself about the old place. In the mill, life and activity seemed to reign. The old furnaces, as in years past, are seen again in full blast; while from the stacks fire is shooting heavenward. In the works everything appears full of life. Bosses and firemen that long ago passed away can again be seen busy in their respective duties. The huge old rolls groan and snap under their heavy weight, while the old familiar "side" waterwheel is again observed at these times running like a race horse.*

Weisberg also tells tales about the Weweantic Iron Company site in South Wareham, which burned and killed many workers, who are now reported to wander the area. The company rebuilt, but each time it did, the works would burn again. This happened three times.

In Onset, the spirits were also active, Weisberg suggests. He tells of a female apparition walking along the beach at Onset Bay and of ghostly smoke and drums beating on Wickets Island, where a violent storm in 1815 reportedly washed many graves of the Wampanoags into the bay.

The author also mentions the wigwam in Onset, but only to say that it's no surprise that ghosts are associated with an area that welcomes and invites them. Weisberg writes:

> So many stories have come out of the cottages that surround the wigwam and the Victorian houses that dot the waterfront, but unlike other ghost stories in which the spirit is a tragic figure, these spectral visitors are considered old friends there to lend a ghostly guiding hand.

MAKING A SPLASH

A well-known boat company made Wareham its home in 2004. Although not located on the waterfront, the Beetle Boat Shop recalls the days when shipbuilding was a key part of the local industry.

Named for the Beetle family of New Bedford, the company was famous for its whaleboats, but when the industry died, it shifted production to the Beetle Cat boat. According to the company website, the Beetle family suspended production during World War II and then sold the business to the Concordia Company of South Dartmouth. The new company developed the Beetle Cat mold and other patterns still used today.

In 1993, Beetle Inc. was founded by Charlie York, who sold it to Bill Womack in 2003. In 2004, Womack moved the operation to Wareham. The new space allows for construction, has additional storage space and provides room to build larger, traditional wood boats, like the twenty-eight-foot Hanley Catboat *Kathleen*.

Horseshoe Pond was back in the news in 2012 when $85,000 was provided by Massachusetts's Energy and Environmental Affairs Conservation Partnership Grant Program to the Coalition for Buzzards Bay to purchase a nine-acre parcel between the town and the Wildlands Trust property. The site preserves a trail link around the northern and eastern edges of the pond and includes the remains of the historic mill operations. The coalition will also work with the state's Division of Ecological Restoration to maintain and restore the cold-water fishery in the area.

Horseshoe Pond, which was also known as Wareham Nail Works Pond and Federal Horse Shoe Pond, plays an important role in the life of rainbow smelt. The Weweantic River is the site of the state's only licensed rainbow

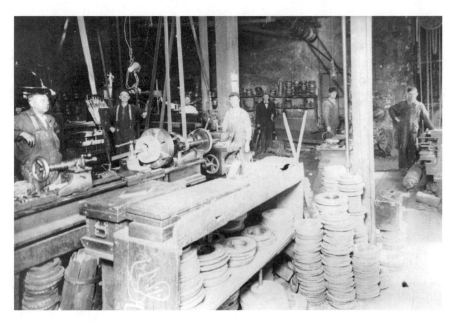

The horseshoe mill was located in South Wareham. Pictured are (left to right) Dan Dennis, Felix Coyne, Charles Bump, Howard Hollis, Felix Kiernan and William Coyne. *Wareham Free Library.*

smelt run. According to Dr. Joe Costa's report on alewives for the Buzzards Bay National Estuary Program, the smelt lay their eggs in the brackish water of the lower river to Horseshoe Pond dam.

A Boston nonprofit group, Preservation of Affordable Housing Inc., purchased Brandy Hill Apartments. The 132-unit housing complex on State Street in East Wareham did not involve the town, but the hope was that it would help provide much-needed affordable housing.

CHANGING VISTAS

Although the Tremont Nail Factory closed and its new owners moved the nail machinery to Mansfield, the Old Company Store remains open. Originally, it was a factory store for employees and then became a gift shop for tourists in about 1969. When the nail production was moved to Mansfield in the mid-1990s, the store was going to be closed by the factory's new owners. That's when the current owners took over the shop.

The store was transformed into a 1950s store by Shari Aussant in about 1994 with her sister, Cindi Assad von Hahle, and their mother, Sandra Assad. Aussant explained what happened in a 2009 *SouthCoast Business Bulletin* article:

> *What we did was, we kept the products, but if you were a tourist in the 1950s, that's the kind of feel you'd have if you walked into a shop. The hospitality is there, that old-style hospitality; we always had that, but it's just amplified.*

The family is also known for offering customers hot coffee and for giving back to the community. Among their efforts was hosting a prom party for Womenade of Wareham's Prom Closet, at which women were treated to food and music from the 1970s and '80s. More than three hundred dresses and about $350 in donations were collected, according to wickedlocal.com.

But not all Wareham retail is retro. Wareham Crossing, a 675,000-square-foot open-air shopping center, opened in 2007 and features more than forty stores and restaurants. In 2014, it includes retailers such as Target, Lowe's, L.L. Bean Outlet, Old Navy and Staples, among other stores, as well as restaurants like LongHorn Steakhouse and Red Robin. Located on Cranberry Highway near the intersection of Routes 495 and 195, the shopping center is owned by WS Development and features wide sidewalks and landscaping that includes a small lighthouse.

The University of Massachusetts Cranberry Station celebrated its centennial in 2010. In its one-hundred-year history, the staff's research has resulted in a variety of improvements ranging from frost forecasting to insect monitoring and modern fertility management. Its website suggested that the future will bring more research in "effective and sustainable practices in pest, nutrient, and water management."

A sweet addition to the local economy took place in 2011, when, according to the company website, Dorothy Cox's Chocolates moved its factory and office to Wareham. The Fairhaven, Massachusetts–based company has been family owned since 1928. Well known for its buttercrunch candy, which is still produced by hand, as well as panned items and other treats, it also continues to sell from its Alden Road, Fairhaven store.

The Spinney Memorial Library reopened in 2011, about sixty-five years after it closed its doors. Although refurbished, according to the *Boston Globe*, it initially operated just like it did before World War II: on the honor system.

Wareham Crossing is a modern shopping destination with landscaping that includes its own lighthouse. *Michael J. Vieira.*

Patrons can borrow books and return them, along with some of their own to add to the collection, without an official checkout system.

In addition to books, the library has another hook: lending fishing rods. Bait, however, must be purchased at the hardware store around the corner. The Friends of the Wareham Free Library was offered free use of the

building in 2005 and did a major restoration of the space. Funding came primarily from donations and fundraising events.

Recognizing a need for affordable housing for elders in the community, Wareham issued a request for proposals in June 2012 to build a minimum of 150 and a maximum of 280 senior housing units on seventeen acres of land known as Westfield on Charlotte Furnace Road. Housing remained an issue in 2013, when the Wareham Housing Authority came under review by the Massachusetts Department of Housing and Community Development after a number of "filed complaints." The report, according to a *Standard-Times* article, cited "failure to certify a 2013 budget, poor board participation, inadequate internal controls, insufficient management plan, inappropriate tenant selection and lack of annual inspections." A change in leadership was expected to bring improvements.

During the same year, the town issued a "Housing Production Plan," which presented an overview of the housing situation and suggested strategies to meet state goals. Although the report suggests that significant progress was made in meeting the state's affordability requirements, Wareham would have to produce "at least 49 affordable units annually" to meet production goals. That is, the report stressed, a formidable challenge.

Onset Avenue is still a busy thoroughfare, especially during the summer. *Michael J. Vieira.*

147

In addition to housing, where to put the many vehicles that pass through town remains a challenge. Especially during the summer, parking is a problem in Onset Village. A public presentation in December 2013 demonstrated the results of a survey and outlined some recommendations.

Key principles included the need to protect residential parking, provide employee parking, improve lighting and safety, encourage visitors to use designated lots and increase availability of "front door" parking. Among the recommendations were increasing the number of parking spaces and lots, changing the fee structure, creating better signage and encouraging the use of pedicabs and bicycles.

Preliminary discussions about a Wareham Community Pathway began in 2011. A five-phase plan has been proposed for a twelve-mile pathway that would start at Blackmore Pond Road just beyond where it intersects with County Road and then follow the abandoned rail line to Fearing Hill Road. From here, a number of possibilities exist, according to the group's website, but ideally the finished route would connect West Wareham to the Marion Bike Path and pass through Wareham to Buzzards Bay.

Planning for Open Space

In 2010, the Town of Wareham published an Open Space and Recreation Plan for 2010–17. In it, it describes the town as having fifty-seven miles of coastline—more than any other community in Massachusetts. That said, the report also pointed out that much of the shoreline remains in private ownership and access is limited.

This is especially true in areas like Swift's Beach, Indian Mound Beach, Parkward, Pinehurst, Rose Point, Weweantic Shores and Briarwood, which were originally developed as summer homes. The report notes that most have small yards and lot sizes smaller than currently allowed. Even inland, developments like Shangri-La, Aga-Pine, Pine Tree Estates and Westfield provide little open space.

An Action Plan was developed to address the town's needs. It includes priority areas for permanently protecting open space through land acquisition, conservation restriction or other means. The report also set the following goals: protect land of high natural, environmental, scenic and recreational value; expand and improve recreational facilities; increase and enhance opportunities to enjoy open space and recreational facilities;

and promote public education of environmental issues, sustainability and green living.

Also in 2010, the Century Bog was acquired from A.D. Makepeace, completing what Steve Hurley of Massachusetts Fish and Wildlife's Southeast District called a "140-plus-year love affair." Samuel Tisdale, a Wareham nail manufacturer, is credited with introducing smallmouth bass to Massachusetts in 1850. The fish, then known as "Black Bass," arrived by "milk can and railroad" to Flax Pond in Wareham.

When Tisdale offered up some land to establish the first trout hatchery, Theodore Lyman III was introduced to the Salter brook trout of Red Brook, Wareham. Lyman, an aide-de-camp to General George Meade in the Civil War, became one of the state's first commissioners of fisheries and set out to restore Massachusetts's fisheries that had been "degraded by industrial development, dams, overharvest and pollution."

In 1870, Lyman purchased property along Red Brook, which his family maintained until the late 1980s, when they contacted Trout Unlimited to continue protecting the cold-water fishery. In 2001, the Trustees of Reservations took over the property.

With the help of A.D. Makepeace, dams were removed in 2006, 2008 and 2009. In 2011, the company, which would be allowed to farm cranberries for another five years, sold Century Bog, which will allow for the future habitat restoration of upper Red Brook and will protect the river from its headwaters to the sea.

A VISION FOR THE VILLAGE

The Cecil Group and FXM Associates produced a document in 2008 that offered a strategy for Wareham Village. The village is bounded by Cedar, Elm and High Streets and the Wankinco River. It includes the rail line, hospital and a combination of residential and commercial buildings. The report provides the follow description and goal:

> *Wareham Village is a unique, small scale New England village center that provides places to live, shop and work in a setting that is linked directly to the water's edge. The Village Center primarily serves the citizens of the Town and those visitors that are drawn to the picturesque center that is genuine, historic and pleasant. It is easy to get around on foot, in a car or*

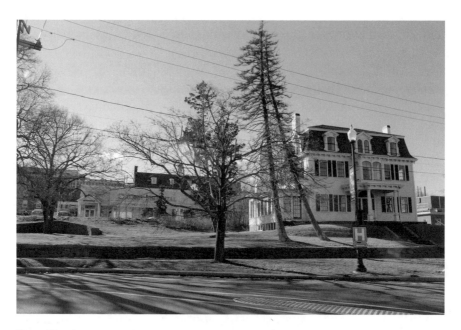

Tobey Hospital would continue to play an important part in a renewed Wareham Village. *Michael J. Vieira.*

on a bicycle, it has the right amount of convenient parking. It is not so much a new place, but a brightened, lively district largely composed of small and renovated buildings along the treelined, landscaped Main Street.

In 2011, $477,000 was requested to fund the first construction phase of Village Streetscape improvements. Community Development Block Grant (CDBG) funds were requested for the project. CDBG funds also were requested for the twenty-year Housing Rehabilitation Program, which provided deferred payment and low-interest loans to low- and moderate-income house owners who want to make home repairs.

Wareham is also part of the South Shore/Canal Regional Economic Development District and the South Shore/Canal Technology Corridor. These groups encourage technology companies to call nearby Plymouth and the rest of the region home.

Among the Wareham companies is Smithers Pharma Services. According to the corridor's website, Smithers provides services to pharmaceutical, biotechnology and consumer healthcare industries that help them move through the drug development process from preformulations to market registration.

In 2014, the last lightship built in the United States, the *Nantucket II*, was docked in Wareham after being restored by Jack Baker. It was placed on the market in 2002, but no buyer apparently was found. The ship was commissioned in 1952 and is unique, lighthousefriends.com says, because of its tripod foremast topped by a cylindrical, lighthouse-style lantern room, which houses the brightest beacon of all American lightships.

It served at Ambrose Station in Texas until 1967, and for the next twelve years, it was a relief lightship in Massachusetts. It served alternating assignments at Nantucket Shoals with *Nantucket I*. It was relieved of duty in 1983 after a large navigational buoy was activated.

Since then, the lightship was cared for by the New England Historic Seaport group until 1996, when Schools for Children offered it for sale. Friends of the Lightship took it under its care until 1998, when Baker bought it. It last sailed in 1999 when it made a trek to New Bedford, Massachusetts, to be part of a memorial to those who lost their lives aboard lightships.

In 2014, the *Nantucket* is docked at the mouth of the Agawam River in Wareham, not far from where Route 6 crosses the Narrows.

It's not the only bright spot in town.

A ROSEBROOK BLOOMS

Rosebrook Place, at the intersection of Interstates 195 and 495, is a new development on land owned by A.D. Makepeace. SouthCoast Hospital opened a medical facility there, and in 2013, a groundbreaking ceremony was held for TownPlace Suites Marriott Hotel, a four-story facility being built by the Lafrance Hospitality Group.

The ninety-room hotel is the first to be built in Wareham in twenty years and will include a bar, breakfast restaurant, indoor pool and exercise room. It also includes a ten-thousand-square-foot conference center. Makepeace hopes that Rosebrook Place will be a mixed-use development with restaurants, retail and other companies that want to take advantage of the site, according to the 2013 Rosebrook Place brochure. In addition to the SouthCoast Health Complex, which opened in 2011, there is a Cape Cod Five Bank branch located just off Route 28.

The A.D. Makepeace Company, which is based in Wareham, is the world's largest cranberry grower, and a thirty-acre working bog that connects Rosebrook Place with Rosebrook Business Park has been integrated into the

Rosebrook Place design. The company is also the largest private property owner in eastern Massachusetts with about fourteen thousand acres of land in Wareham, Plymouth, Carver and Rochester.

Although Wisconsin is now the largest producer of cranberries in the country with 4.41 million barrels produced in 2011, Massachusetts is second with 2.35 barrels. The entire nation's crop was 7.74 barrels in 2011, according to the USDA National Agricultural Statistics Service. Wareham has more than 1,500 acres of cranberry bogs, making it one of the top producers in the state.

Not far from Rosebrook Place and Crossroads Plaza, a new Walmart Superstore is slated to open in 2015 after several years of debate and permitting. Among the final hurdles was a "conservation management permit" from the state's Department of Environmental Protection that will allow Walmart to build an eastern box turtle habitat as part of the project.

Located in West Wareham near Tobey Road and Cranberry Highway, the 160,000-square-foot store will replace the current Walmart in Cranberry Plaza in East Wareham. Although anchored by Stop & Shop and home to several stores, the plaza has been overshadowed by Wareham Crossing and other new developments. The property sheet from Davenport Properties lists the plaza as 196,852 square feet of space, which is approximately 80 percent leased.

Hope for the Future

Tremont Nail Factory, which the town purchased in 2006 when the brand moved to Mansfield, continues to sit empty near what was the busy center of town. Johanna Rowley, a Wareham native and professional designer/preservationist, presented some ideas that could change that.

In a *GateHouse* media article by Caitlyn Flaherty in 2013, Rowley, an adjunct faculty member at Boston Architectural College, proposed having her students participate in a long-term project that would include researching the site, designing future concepts and involving the community in exploring ways to reuse the factory. Rowley and her students also hope to spearhead overall improvements to the town.

Other improvements could also help the environment.

After being closed for many years, 90 percent of Buttermilk Bay is now open to shellfishing and recreational activities, according to a U.S. EPA

report in 2012. Improvements to the storm water control systems in Bourne and Wareham were credited for the recovery of the bay.

In the future, the sun won't be a welcome sight only to those at the beach. In 2013, approval was granted to EDF Renewable Energy to start construction of the Lepomis Solar Project. Although located in Plymouth, it will provide power to Wareham under a long-term power purchase agreement. The 5.96-megawatt ground-mounted, fixed-tilt solar photovoltaic project should be ready to power up in the spring of 2014.

CELEBRATING 275 YEARS

The summer of 2014 will mark the 200th anniversary of the attack by the HMS *Nimrod* and the 275th anniversary of the incorporation of Wareham. Beginning in June, among the events planned are a historical exhibit on the War of 1812, a Revolutionary War and War of 1812 troop encampment and a reenactment of the attack of Wareham.

The celebration continues with a clambake, ecumenical service and blessing of the fleet, historical displays, a town birthday party, a Founders' Ball and hand tub fire muster and public safety events. The planning committee for the Wareham Summer of Celebration was coordinated by Claire Smith. The committee executive team included Rudy Santos, president; Nancy Miller, vice-president; Angela Dunham, clerk; and Robert Powilatis, treasurer. The board of directors was composed of members Malcolm Phinney, Jovina Dean, Eleanor Martin, Sharon Boyer and W. Robert White, and committee members included John McGonnell, Deborah McGonnell, Paula Tufts, Nora Bicki, Clifford Sylvia, Mel Lazarus, William Heaney, Laura Lopes, Jacqui Healey and Linda Burke.

EPILOGUE

Bringing the Past and Present Together

When the celebrations end, perhaps the best way to appreciate where Wareham has been and where it can be is to leisurely walk through historic areas near Center Park or to stand on the beach or on the bluffs looking over the sparkling waters as the native peoples, settlers and visitors have done for tens of thousands of years.

Although many drive past it on the new interstate or through it on the Cranberry Highway, Wareham's history is also best appreciated by slowing down, taking the scenic routes and exploring the districts as outlined in the Wareham Historical Commission's Preservation Plan.

Agawam Village

This section of East Wareham where Route 6 and Depot Street cross includes the Agawam Herring Run and dam, Agawam Hall and good examples of early eighteenth- to nineteenth-century homes. The river was important to both the native peoples and the early settlers.

CENTER PARK–PARKER MILLS

The old Tremont Nail Factory may dominate this area, but the streets that surround it and the green space at its heart include many colonial-era buildings. This area was the historic center of town and contains some of Wareham's most intact examples of industrial and residential structures from the early days of the settlement.

Across from Center Park are three buildings that were relocated to the area: the Great Neck Union Chapel, the Old Methodist Meeting House and Schoolhouse No. 6. In 2013, emergency repairs were made, but much work remains to be done on these historic structures.

COUNTY ROAD

This rural road was known as Briggs Road until 1739, when Wareham separated from Rochester. It was then called Division Road because it marked the new boundary. Although the house at what is now 768 County Road dates back to the 1740s, most of the homes' architecture range from the nineteenth-century industrial era to the twentieth century and include Craftsman houses.

GREAT NECK ROAD

Just south of Agawam Village, Great Neck Road travels through what was the center of the Agawam Purchase of 1666. It remains rural with good examples of eighteenth- through twentieth-century single-family houses. Agawam Cemetery, laid out in 1685, and Broad Marsh, a source of salt for more than two hundred years, are located in the area.

INDIAN NECK

This wooded peninsula was originally used as pasture land by the settlers, but there is evidence that it was a Native American encampment before the

Europeans arrived. There are good examples of historic summer homes, but the views of Bourne Cove and Buzzards Bay have remained relatively unchanged over the centuries.

THE NARROWS

This is where the HMS *Nimrod* attacked Wareham during the War of 1812 and where the town's shipbuilding industry was centered. Across the road, the Tobey Homestead and other important large homes from the late eighteenth to mid-nineteenth century, including the Captain Kendrick House and Maritime Museum, stand. The area became a historic district in 1986.

Aquene, and many other folks, ponders the future of Onset and Wareham. *Michael J. Vieira.*

ONSET VILLAGE

The largest and most intact of Wareham's historic summer communities includes a main commercial street, large resorts and small cottages, as well as public beaches and parks, like the Bluffs. At the heart of Onset Village is Dudley L. Brown Square, in memory of a U.S. Marine who died in World War I.

POINT INDEPENDENCE

Just across the East River, this residential area is similar to Onset Village with larger homes near the water and smaller cottages set back on smaller lots. The Bay Pointe Golf Club is located in this area, as is the Point Independence Yacht Club.

RLDS CAMP

The Reorganized Church of Latter Day Saints (RLDS) Camp is located north of Onset Village. It began as a tent city in 1911, but over the years, cottages and bungalows replaced the tents. In 1920, the tabernacle was built, and in later years, a contemporary chapel was added.

SWIFT'S BEACH

Located on a broad peninsula at the mouth of the Wareham River, Swift's Beach is reached by a road of the same name off Route 6. Although some homes have been expanded and others renovated, for the most part, the area remains an excellent example of early to mid-twentieth-century summer communities.

TREMONT VILLAGE

This area included the Tremont Mill Pond and the Tremont Dam, as well as several examples of single-family, double houses and what was a company

Main Street in 2014 still retains some of the small-town charm that it had when thousands of cars drove through when it was truly the Gateway to the Cape. *Michael J. Vieira.*

store and meeting hall. Tremont Village is located at the intersection of Weaver, Mill and Main Streets and Gault Road near where the Washington Iron Works and later Tremont Nail Factory were located.

TIHONET VILLAGE

Tihonet Village includes a double house that was used by workers and three single houses, along with the Tihonet Dam and Tihonet Pond. Although the mill buildings no longer exist, the Preservation Plan notes that it provides "important remnants of a self-contained mill village" that was located along the Wankinco River.

WAREHAM VILLAGE

The historic commercial area of Wareham consists of Main Street from Agawam Road and the Narrows Bridge to Sawyer Street. Although

the area includes some residential architecture, it is mostly made up of one- to three-story commercial buildings or converted housing. It also includes the "prominent heritage landscape features" of the Wankinco and Agawam Rivers.

TWENTIETH-CENTURY PLANNED COMMUNITIES

Although not often considered historic resources, the Wareham Preservation Plan acknowledges the early to mid-twentieth-century summer communities. These include Agawam Beach, Barney's Point/Parkwood Beach, Briarwood, Cromesett Park, Jefferson Shores, Pinehurst Beach, Riverside, Rose Point, Shangri-La/White Sand Shore and Swift's Beach/Swift's Neck.

BIBLIOGRAPHY

Aamidor, Abraham. *Chuck Taylor, All Star: The True Story of the Man behind the Most Famous Athletic Shoe in History*. Bloomington: Indiana University Press, 2006.

Agawam Plantation Land Records. Wareham, Massachusetts, 1685 to mid-18th Century. Plymouth Archaeological Rediscovery Project (PARP) Digital Copy, November 2012. http://www.scribd.com/doc/114170336/ Agawam-Plantation-Land-Records-Wareham-Massachusetts.

Allen, Everett S. *A Wind to Shake the World: The Story of the 1938 Hurricane*. Boston: Little, Brown, 1976.

Angelo, Bernadine Rose. "Beckoning the Red Man's Spirit: Exploring the Boundaries of Gender, Race, Sacred and Commercial Spaces at the Wigwam Spiritualist Temple, Onset, Massachusetts, 1880–1913." Master's thesis, University of Massachusetts–Boston, 2010.

Banner, Earl. "The Wreckage Carol Left Behind." *Boston Globe*, September 5, 1954.

Berard, Pamela. "Ingenuity Keeps Wareham Retail Shop on Top." *SouthCoast Business Bulletin*, March 27, 2009. http://www.southcoasttoday.com/ apps/pbcs.dll/article?AID=/20090327/SCBULLETIN/904010333.

Boston Daily Globe. "Peanuts, Spirits and a Good Time." July 13, 1891.

"A Brief History of Onset." http://www.hollyhurstcottageinn.com/ onsethistory.htm (accessed January 30, 2014).

Burgess, Ebenezer. *Wareham: Sixty Years Since a Discourse Delivered at Wareham, Massachusetts, May 19, 1861*. Boston: Marvin and Son, 1861.

"Buzzards Bay." Success Stories. U.S. EPA, March 6, 2012. http://water. epa.gov/type/oceb/nep/success.cfm.

Caires, Olive, Ben Dunham, Thornton Gibbs, Ray Rider and Ellen Walcek. "A Tour Guide of the Fearing Tavern in Wareham, Massachusetts." Unpublished booklet, Wareham Historical Society, July 1986.

Carr, Virginia Spencer. *Dos Passos: A Life*. Evanston, IL: Northwestern University Press, 2004.

Cloud, Tom. "Just a Bunch of Beads (Wampum and Currency in the U.S.)." *Cloud Family Association Journal* 29, nos. 1–4: 82–86. http://mykindred. com/cloud/TX/Documents/dollar/Wampum.php#.UqvGWuJJuuw.

"Conant Hill Preserve." Wildlands Trust. Duxbury, MA. http://www. wildlandstrust.org/Portals/0/Uploads/Documents/Public/2012/ Conant%20Hill%20Preserve%20Summary%20and%20Trail%20Map. pdf (accessed February 2, 2014).

Conditions Assessment and Feasibility Study, Tremont Nail Factory, Wareham, Massachusetts. Boston: Menders, Torrey & Spencer Inc., June 2009.

Cooke, Robert. "Southeastern Mass. Quake Tumbles Dishes." *Boston Globe*, December 21, 1977.

Costa, Joe. "The Historical Alewife Run on the Weweantic River Bumpto Carver." Buzzards Bay National Estuary Program. http://buzzardsbay. org/weweantic-herring-historical.html.

Cox, Robert S., and Jacob Walker. *Massachusetts Cranberry Culture: A History from Bog to Table*. Charleston, SC: The History Press, 2012.

Cranberry Plaza, Davenport Companies, Boston, MA. http://www.dvnpt. net/docs/property_downloads/ma_wareham_cranberryplaza.pdf.

Cultera, Larry. *Classic Diners of Massachusetts*. Charleston, SC: The History Press, 2011.

Daily Boston Globe. "All Over Again…Floods, Blackouts Widespread in N.E." September 12, 1954.

Danoconnell. Posting in Wareham Water, July 27, 2009. http:// warehamwater.com/viewtopic.php?id=5433.

Doty, Ethan Allen. *Doty-Doten Family in America: Descendants of Edward Doty, an Emigrant by the Mayflower, 1620*. Madison, WI: E.A. Doty, 1897. Digitized September 21, 2007.

"EDF Breaks Ground on 5.96 MW Massachusetts Solar Project." *Solar Industry*, October 22, 2013. http://www.solarindustrymag. com/e107_plugins/content/content.php?content.13373#utm_ medium=email&utm_source=LNH+10-23-2013&utm_ campaign=SIM+News+Headlines.

Eldredge, Nancy. "Who Are the Wampanoag?" Plimoth Plantation, 2013. http://www.plimoth.org/learn/just-kids/homework-help/who-are-wampanoag.

Everett, Noble Warren. "History of Wareham." In *History of Plymouth County, Massachusetts with Biographical Sketches of Many of Its Pioneers and Prominent Men*. Compiled by D. Hamilton Hurd. Philadelphia: Lewis and Co., 1884, 191. https://openlibrary.org/books/OL24156241M/History_of_Plymouth_County_Massachusetts.

Falacci, Frank. "Cape Storm Loss Tops Million." *Boston Globe*, September 13, 1961.

Federal Writers' Project. *Massachusetts: A Guide to Its Places and People*. St. Clair Shores, MI: Scholarly Press, 1937. Reissued by North American Book, January 1, 1973, 285. http://books.google.com/books?id=yrU2IrDGI1 0C&dq=stagecoach+routes+Massachusetts&source=gbs_navlinks_s.

Flaherty, Caitlin. "Groundbreaking Held for New Marriott Hotel at A.D. Makepeace's Rosebrook Place." WickedLocal.com, November 13, 2013. http://www.wickedlocal.com/x1275642218/Groundbreaking-held-for-new-Marriott-Hotel-at-A-D-Makepeaces-Rosebrook-Place.

———. "Hammering Out Tremont Nail's Restoration in Wareham." *GateHouse Media*, February 7, 2013. http://www.wickedlocal.com/article/20130207/NEWS/302079543.

Freeland, Chrystia, and Mary DeWitt Freeland. *The Records of Oxford, Massachusetts: Including Chapters of Nipmuck, Huguenot and English History, Accompanied with Biographical Sketches and Notes, 1630–1890, with Manners and Fashions of the Time*. Reprint. Baltimore, MD: Genealogical Publishing, 2009.

Friss, Gwenn. "Diners through the Decades." *Cape Cod Times*, March 4, 2009.

Griffith, Richard W. "Revolutionary War Soldiers and Sailors from Wareham, Massachusetts." http://www.warehamhistory.com/WarehamGenWeb/RevWar.htm (accessed January 5, 2013).

———. Wareham Historical Notes. Last modified September 10, 2013. http://www.warehamhistory.com/WarehamGenWeb/WrhmHist.htm.

"History of Cranberries." Cape Cod Cranberry Growers' Association, 2014. http://www.cranberries.org/cranberries/history.html.

History of Wareham. Scanned and reformatted from the Plymouth County Directory and Historical Register of the Old Colony. Middleborough, MA: Pratt, 1867. http://www.warehamhistory.com/WarehamGenWeb/Wareham_History_1867.htm, 1.

"Home Page." On-I-Set Spiritualist Camp, NSAC, 2013. http://www.onisetwigwam.com/Home_Page.php (accessed January 21, 2014).

"Horseshoe Mill." Buzzards Bay Coalition. http://www.savebuzzardsbay.org/DiscoverBay/FindAnAdventure/OurConservationAreas/HorseshoeMill (accessed January 19, 2014).

Howe, Peter J. "New Road to Cape Ready to Open." *Boston Globe*, August 8, 1987.

Hurley, Steve. "Century Bog Acquisition." 2011 Massachusetts Fish and Wildlife Guide to Hunting, Freshwater Fishing and Trapping. http://www.eregulations.com/massachusetts/huntingandfishing2011/century-bog-acquisition (accessed February 3, 2014).

"Incoming Letters, 1848–49, Dec. 6, 1848 and Oct. 5, 1848 (case 2), Records of Parker Mills and Tremont Nail Company, 1845–1918." Baker Library Historical Collections, Harvard Business School. Cited in the *Tremont Nail Factory Feasibility Study*. Boston: Menders, Torrey & Spencer Inc., June 2009.

Jerome, Sibyl. *Wareham 1776–1976: Revolution and Bicentennial*. Wareham, MA: Wareham Bicentennial Commission, 1977.

Kline, Nat. "Wareham Grits Its Teeth, Braces for 2d Onslaught." *Daily Boston Globe*, September 11, 1954.

Legere, Christine. "Old-style Library Set to Reel in Readers, Anglers." *Boston Globe*, June 19, 2011.

"Lightship *Nantucket II* WLV 613, MA." Lighthouse Friends, 2014. http://www.lighthousefriends.com/light.asp?ID=613.

Lincoln, James R. *Prescription Filled*. Taunton, MA: Sullwold Publishing, 1981.

Lodi, Edward. *Women in King Philip's War*. Middleboro, MA: Rock Village, 2012.

Mann, Charles. "Native Intelligence." Smithsonian. http://www.smithsonianmag.com/history-archaeology/squanto.html?c=y&page=3.

"Massachusetts Cranberries." U.S. Department of Agriculture, March 15, 2012. http://www.cranberries.org/pdf/2011_nass_finalreport.pdf.

"MHC Reconnaissance Survey Town Report: Wareham." Boston: Massachusetts Historical Commission, 1981. http://www.sec.state.ma.us/mhc/mhcpdf/townreports/SE-Mass/wrh.pdf.

Moore, William D. "To Hold Communion with Nature and the Spirit World: New England's Spiritualist Camp Meetings, 1865–1910." In *Exploring Everyday Landscapes: Perspectives in Vernacular Architecture*. Vol. 7. Edited by Annmarie Adams and Sall McMurry. Knoxville: University of Tennessee Press, 1997.

Nartonis, David K. "The Rise of 19th-Century American Spiritualism, 1854–1873." *Journal for the Scientific Study of Religion* 49, no. 2 (2010).

Nason, Reverend Elias. *A Gazetteer of the State of Massachusetts*. Revised by Geoge J. Varney. Boston: Russell, 1890.

Neary, James J. "Vast Cape Damage Day After Reveals." *Boston Globe*, September 16, 1944.

Newman, Eric P. *The Early Paper Money of America*. Iola, WI: Krause, 1990.

OnsetIsland.com, 2009. http://onsetisland.com/history.asp (accessed January 21, 2014).

Ottke, Florence Spinney. "The History of Onset." Unpublished paper, July 1977.

"Our History." Church of the Good Shepherd. http://www. goodshepherdwareham.org/history (accessed January 19, 2014).

Pizzolato, Susan, and Lynda Ames Byrne. *Images of America: Wareham*. Charleston, SC: Arcadia Press, 2002.

"Project History." Wôpanâôt8âôk Language Reclamation Project. http:// wlrp.org/History.html.

Public Archaelogy Lab. *Wareham Reconnaissance Report*. Massachusetts Department of Conservation and Recreation Heritage Landscape Inventory Program, December 2001. http://www.mass.gov/eea/docs/ dcr/stewardship/histland/recon-reports/wareham.pdf.

Querino, Kenneth J. Semedo. *The Story Must Be Told: A Story of Cape Verdeans*. Self-published, 1999. http://www1.umassd.edu/specialprograms/ caboverde/cranberry/semedo3.html.

Regan, Keith. "Church Ringing in the Old." *Standard-Times*, June 28, 1996.

Rider, Raymond A. *The Fearings and the Fearing Tavern with the Bumpus Family*. Taunton, MA: William S. Sullwold, 1977.

Ridley, Scott. *Morning of Fire: John Kendrick's Daring American Odyssey in the Pacific*. New York: William Morrow, 2010.

Rios, Simón. "State: Wareham Housing Authority Abused Public Funds, Trust." *Standard-Times*, September 13, 2013.

Russell, Caitlin. "West Wareham Walmart Coming in Early 2015." *Wareham Week*, November 26, 2013. http://wareham-ma.villagesoup.com/p/west-wareham-walmart-coming-in-early-2015/1085392.

The Shipbuilding Facilities Available at Wareham Shipyards. Wareham, MA: National Fireworks, n.d.

"Shout Bands." Notes on the Music District, 106. http://www.folkstreams. net/context,106 (accessed February 2, 2014).

Shultz, Eric B., and Michael J. Tougias. *King Philip's War: The History and Legacy of America's Forgotten Conflict*. Woodstock, VT: Countryman Press, 2000.

Slotkin, Richard, and James K. Folsom. *So Dreadfull a Judgement: Puritan Responses to King Philip's War 1676–1677*. Middletown, CT: Wesleyan University Press, 1978.

"Some Account of the Vampires of Onset, Past and Present." Booklet, 1892.

Sparling, Georgia. "Church in the Pines Celebrates 150 Years." *Wareham Week*, January 2, 2014.

"Station History." UMass Cranberry Station. UMassAmherset, 2014. http://www.umass.edu/cranberry/thestation/st_history.html.

Sullivan, Elisabeth A. "Unlocking the Cranberry Mystique." *Market News*, November 15, 2008. http://www.marketingpower.com/ResourceLibrary/Publications/MarketingNews/2008/42/19/10-11_MN11.15.08.bic.pdf.

Sultzman, Lee. "Wampanoag History." First Nations Histories. http://www.tolatsga.org/wampa.html.

Thomas, Joseph D., ed. *Cranberry Harvest: A History of Cranberry Growing in Massachusetts*. New Bedford, MA: Spinner Publications, 1990.

"Timeline." American Revolution Center. http://timeline.americanrevolutioncenter.org (accessed January 5, 2014).

Town of Wareham Open Space and Recreation Plan, 2010–17. Report prepared for the Town of Wareham by the Open Space Committee.

"Veteran's Agent." Wareham, MA. http://www.wareham.ma.us/Public_Documents/WarehamMA_Veteran/index (accessed February 1, 2014).

Wareham: The First Quarter. Wareham, MA: Wareham 250th Anniversary, 1989.

"Wareham Police Department: A Brief History." Wareham Police Department. http://www.warehampolice.com/wp/wp-content/uploads/2011/11/WAREHAM-HISTORY-BRIEF2.pdf (accessed January 20, 2014).

"Wareham Preservation Plan, 2001." http://warehamhistory.org/pdfs/Wareham%20Preservation%20Plan%202007.pdf (accessed January 29, 2014).

Wareham Week. "Brandy Hill Apartments Purchased by Affordable-Housing Nonprofit." July 27, 2010. http://wareham-ma.villagesoup.com/p/2493?source=shareEmail.

Watts, Douglas H. "A Documentary History of the Alewife (Alosa pseudoharengus) in Its Native Habitat in Maine and New England." April 2003. http://www.friendsofsebago.org/alewifemanuscript.pdf (accessed December 31, 2013).

Weisberg, Tim. *Ghosts of the SouthCoast*. Charleston, SC: The History Press, 2010.

Whiting, Lilian. "The Spiritualistic Camp Meetings in the United States." *Annals of Psychical Science* 5, no. 25 (January 1907).

Wikipedia, s.v. "Patuxet Tribe." http://en.wikipedia.org/wiki/Patuxet_tribe.

"Womenade of Wareham Collects Prom Dresses at the Old Country Store." WickedLocal.com, March 31, 2009. http://www.wickedlocal.com/x549586089/Womenade-of-Wareham-collects-prom-dresses-at-the-Old-Company-Sotre?popular=true.

Worth, Henry B. "Highways, Post Roads and Public Houses of New Bedford Before the Arrival of the Railroad Train." Paper presented at the Annual Meeting of the Old Dartmouth Historical Society, March 28, 1921.

"Your Old House: Find Out about Your Old House in Sharon, Connecticut." Sharon Historical Society. http://www.sharonhist.org/historic-houses-places-in-sharon-ct.htm (accessed January 1, 2014).

INDEX

ABOUT THE AUTHOR

D r. Michael J. Vieira retired in 2013 after serving as associate vice-president of academic affairs at Bristol Community College in Fall River, Massachusetts, since 2008. Prior to this, he was dean of business and information management, also at BCC, for five years.

After teaching English and journalism, as well as advising student publications for more than twenty years in Fall River Public Schools, Mike was appointed to a full-time faculty position in 1999 in the BCC Computer Information Systems Department specializing in multimedia applications. Mike also taught as a part-time faculty member at Bristol, Bridgewater State College, Eastern Nazarene College, Roger Williams University and the University of Massachusetts–Dartmouth. He continues to teach each semester.

Mike earned a PhD from Capella University, a BA and MAT from Bridgewater State College and a CAGS from Rhode Island College, as well as certifications from the Commonwealth of Massachusetts. He has developed web pages, written extensively, edited publications and taught and learned online. Mike is an advocate for public education and hands-on learning, including graduate courses in which students are colleagues in learning, engaged as scholar-practitioners.

Throughout his career, Mike has been a freelance writer. He was editor and a regular contributor to the *South Coast Insider* and *Prime Times*, was a columnist and freelance writer for the *Providence Journal* and the *Standard-Times* and was published in other regional papers. He wrote *Camp Noquochoke: A History and Memories* and *InPrint: 100 Years of Scholastic Journalism*, cowrote *The Weather Outside Is Frightful* with J. North Conway and edited *The Blessing: Ghosts of Gage Hill*.

A native of Fall River, Massachusetts, he lives in Swansea with his wife, Audrey. They have two children, Anne and Jonathan.

Visit us at
www.historypress.net

..

This title is also available as an e-book